"*Play, Make, Create* is a wonderful invitation to children's art, combining tried-and-true favorites with creative new ideas. Kids will love doing these fun, process-art activities and parents will love Meri Cherry's simple, no-stress approach to bringing more art and creativity into the home."

—**Jean Van't Hul,** author of *The Artful Parent* book and blog

"This book is so full of invitations to create with your children that, while reading it, you will feel a need to jump up and look through drawers to find all the materials you will need—most of which you probably already have around. Meri is encouraging, generous, and clear with her ideas. Even the most novice artist will find confidence in this book to make art a part of their everyday lives."

—**Samara Caughey,** blogger & owner of Purple Twig art studio for childern in Los Angeles, CA

"For the past nine years, I have been soaking in Meri Cherry's passion, knowledge, and ideas for process art. She is a master at combining simple materials to produce rich and meaningful art experiences. Process art inspires young children to think critically, develop self-regulation skills, and believe in their own creative ideas and abilities. Meri's influence in my own thirty-year teaching practice has given me courage and insight to keep the child's experience at the center of planning for art in my own classroom—my students, and I, absolutely love it."

—**Deborah J. Stewart,** M.Ed., Teach Preschool, LLC

Brimming with creative inspiration, how-to projects, and useful information to enrich your everyday life, Quarto Knows is a favorite destination for those pursuing their interests and passions. Visit our site and dig deeper with our books into your area of interest: Quarto Creates, Quarto Cooks, Quarto Homes, Quarto Lives, Quarto Drives, Quarto Explores, Quarto Gifts, or Quarto Kids.

First Published in 2019 by Quarry Books, an imprint of The Quarto Group, 100 Cummings Center, Suite 265-D, Beverly, MA 01915, USA.
T (978) 282-9590 F (978) 283-2742 QuartoKnows.com

Quarry Books titles are also available at discount for retail, wholesale, promotional, and bulk purchase. For details, contact the Special Sales Manager by email at specialsales@quarto.com or by mail at The Quarto Group, Attn: Special Sales Manager, 100 Cummings Center, Suite 265-D, Beverly, MA 01915, USA.

10 9 8 7 6 5 4 3 2 1

ISBN: 978-1-63159-716-9

Digital edition published in 2019
eISBN: 978-1-63159-717-6

Library of Congress Cataloging-in-Publication Data

Cherry, Meri, author.
Play, make, create, a process-art handbook : with 43 art invitations for kids creative activities and projects to inspire free thinking, mindfulness, and curiosity / Meri Cherry.
ISBN 9781631597169 (flexi-bind) | 9781631597176 (eISBN)
1. Handicraft. 2. Creative activities and seat work.
LCC TT157 .C424 2019 | DDC 745.5--dc23

LCCN 2018054133

Design: Allison Meierding

Photography: Meri Cherry, except Neil Apodaca (pages 70, 71, 92, 116–119, 123), Eryn Kurzeka (pages 102–105, 110), Love Bucket Photo (page 77), Diana Cherry (page 81), Brandilyn Davidson Photography (page 158)

Printed in China

PLAY·MAKE·CREATE

A PROCESS-ART HANDBOOK

With over 40 Art Invitations for Kids

------------------- MERI CHERRY -------------------

CONTENTS

INTRODUCTION

My Spark Moment and Journey

Hello! I'm so thrilled you're here. It means that you're curious about the magic of process art and interested in bringing the power of creativity into your home or learning environment. That makes me really happy.

I started learning about process art about twenty years ago when a teacher came to visit my first-grade classroom to talk about Reggio Emilia–inspired art making. I remember she had an art portfolio filled with photographs of the most incredible child-created art I had ever seen. I saw wire, nuts and bolts, tubes, and all kinds of unusual materials in the photos. I saw drawings of monkeys that looked more like references from a book than the identical construction paper cutouts I saw from most kindergarteners or first graders. Those images made an imprint on my brain I couldn't shake. I wasn't quite sure what it was that attracted me to the photographs. I just knew it was something totally different than anything I had seen children do before, and I was deeply intrigued.

Over the next fifteen years I had more and more opportunities to learn about the Reggio Emilia approach to learning, a child-focused philosophy that homes in on self-driven practices and relationship-driven environments. I took workshops, read books, and visited many schools and classrooms, all while teaching kindergarten through second grade. Then after the birth of my two daughters more than seven years ago, I began doing process art and "invitations to create" based on all my years of learning.

As a working mom, I wanted some way to connect with my girls in the limited time we had together each day. With process art, I found my answer. Almost every night before bed I would set up an art activity for my girls to work on in the morning before I went to work. I remember one morning in particular, as they ran to the table to see what mama had set up for them, my oldest, Gigi, who was three or four at the time, said, "I don't really care what it is. I just like knowing you thought about us." And from that moment on, I was hooked.

Process art is about the journey. It is about listening, connecting, empathizing, and wondering. Process art honors the individual in all of us. It values critical thinking, exploration, thinking outside the box, and the

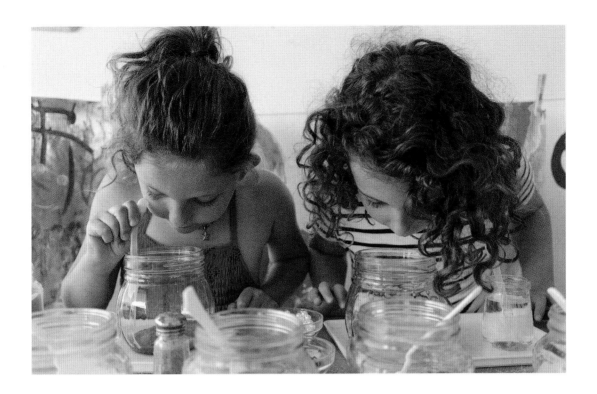

developmental process of each individual. Simply put . . . **Process art is all about the making and the doing, rather than the finished product.** What's not to love about that?

I've packed this book with all of the important things I have learned over the past twenty years of making and creating art with children. Since my fifteen years as a K–2 teacher, I have pioneered a Reggio Emilia–inspired preschool atelier (a.k.a. art studio); taught enrichment classes, private process-based art classes, and sensory play groups to hundreds of children throughout Los Angeles; opened Meri Cherry Art Studio, a thriving process-based art studio in Los Angeles; and learned many a trick or two about how to teach and engage children in art making in a way that honors each individual and their process.

I hope you find a tremendous amount of inspiration here, as well as concrete tools to use in your home or classroom. Most of all, while making art, I hope you experience joy and connection with the children in your life.

There is no right or wrong way to use this book. You can read through the whole thing and highlight the activities and ideas that speak to you. Or, maybe just dive right into the Invitations to Create and try one tomorrow morning. No matter what your pace or strategy, I hope you enjoy the process.

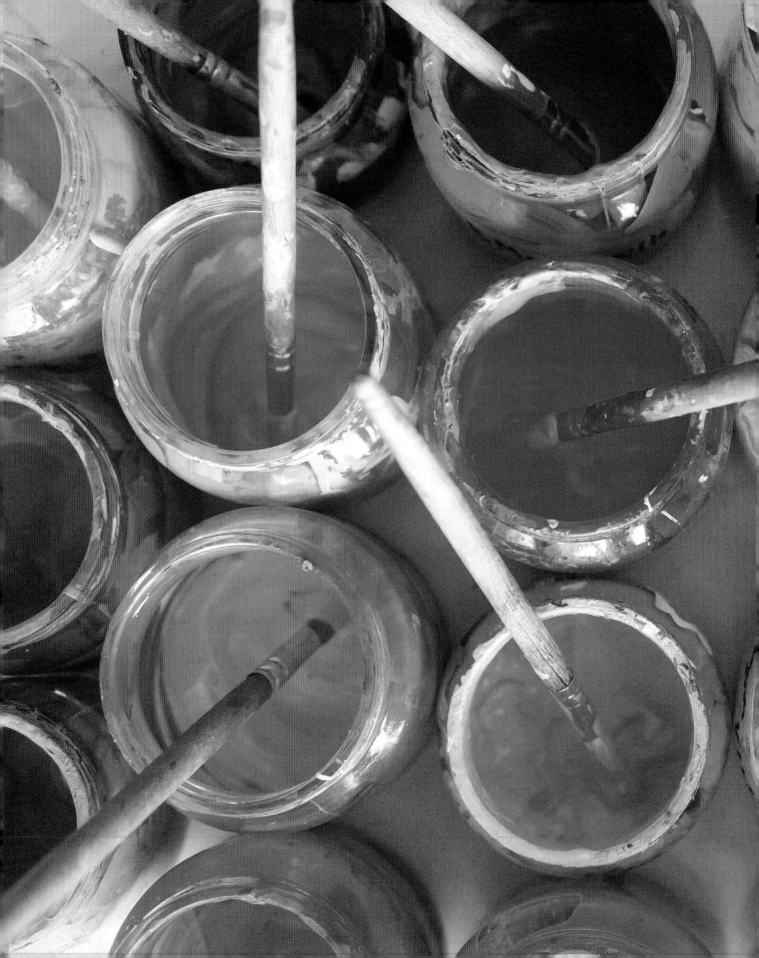

Chapter 1

SETTING THE STAGE TO PLAY

WHAT IS PROCESS ART?

As I mentioned in the introduction, process art is art that is all about the making and the doing, rather than the finished product. That doesn't mean you can't have a totally fantastic finished product. Quite the contrary. It just means that's not the point. I think there is a mind shift that takes place as we, as parents and educators, open our minds to process art. We start to see the beauty in the imperfections of our child's work. We start to love and appreciate the odd shapes, quirky colors, and upside-down faces. We begin to recognize that this art is a special moment in childhood, captured right where the child is developmentally. When we can do that, our children's work becomes beautiful.

WHAT IS AN INVITATION TO CREATE?

Invitations to Create are mini art or play experiences that you can set up for your child to use to explore and create. They are meant to be . . .

Simple
Easy to set up
Engaging

Invitations to Create can be a way to wake up our brains and jump-start them into thinking and doing. They can also be a nice way to decompress and relax. Invitations to Create are an easy way to build fine motor and critical thinking skills through art making. They are also a way to say, "I love you. I thought about you. You're important to me. Your ideas are important to me." Invitations to Create are not meant to stress you out and add to your list of things to do. I like to think of Invitations to Create as little presents we can give to the children in our lives. You might find a present or two in there for you too.

Every invitation may not be a winner in your household, and that's okay. The more you practice, the more you'll figure out what kinds of invitations your kids will love.

I've included more than **thirty** invitations to inspire you. I recommend setting them up when your kids aren't around. This way you have some quiet space to breathe and put care into what you set up for them. There is no right or wrong time to set up an invitation. If the morning seems like a daunting time to do activities, with rushing to school and all that, then maybe save it for the weekends. Or maybe preparing something for after school feels like a better fit. I like to set up invitations after my girls go to bed. They wake up excited to quickly get ready for school so they can see what I set up. Whichever way you decide to do it is great.

In addition to the Invitations to Create, I have included **ten** larger process-based art projects that kids love. Some might be easier than others, but all of them are designed in the spirit of process art—they are meant to be tried, sampled, tweaked, evolved, and enjoyed any way you like. They can also be easily broken down into individual Invitations to Create.

I've been asked, what makes projects process art if you're telling the kids what to do? My answer: To me, if the focus is on the making and the doing, where kids are encouraged to make their own choices about important details, colors, etc., and where language is used to honor individual ideas and creativity, then they are doing process art. Guidance and a plan does not mean it's not process-based art. Each project here uses interesting materials and ideas to engage children ages three to seven, give or take a year or two. I've done my best to reuse as many materials as possible, so if you buy an art supply on my recommendation, it's typically not for a one-time use. You'll notice that some ideas and techniques resurface throughout this book. There is great value in repetition, so don't be afraid to repeat things over and over again.

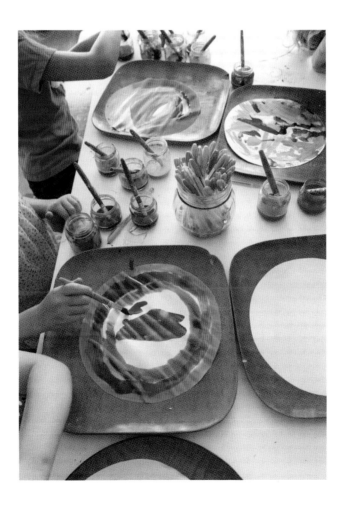

MATERIALS

I've been an art teacher in one form or another for twenty years. I've had a lot of time to figure out what paints I like, why I like them, what scissors to use, how to store paint, etc. One thing I've learned, above all else, is to keep it simple. We don't need fancy pens or the latest glitter glue to have fun. I've done my best to suggest materials here that we use over and over again. With the exception of good watercolor paper, which I am a strong advocate for, nothing is very expensive and you don't have to have any one material here to have a great experience with process art and invitations. In fact, nature is often the best art material out there. Having said that, if you're looking for a starter list of thirteen great art supplies, here you go. We use these materials on many of the projects and I feel confident you will be glad you purchased them. This list doesn't cover every material used in the book, but it gives you a great foundation to always be ready for some art making and creativity.

+ kid's scissors
+ washi tape (Decorative tape—I recommend the MT brand. It actually sticks.)
+ small hammer (Found at your local hardware store.)
+ oil pastels
+ watercolor palette
+ liquid watercolors (or food coloring and water)
+ good-quality watercolor paper (I like the Canson brand.)
+ floral wire (Found at the craft store in the floral department.)
+ white glue
+ black permanent markers
+ pipettes (a.k.a. droppers)
+ chalk markers
+ glue gun
+ art smock or apron

White Gesso or Spray Paint

White gesso (extra-thick white paint from the craft store) and spray paint make just about everything reusable and super pretty. We do a ton of painting on cardboard and wood. It's really nice to give kids a clean white slate to work on, which can easily be achieved with spray paint or white gesso. If you're anything like me, you have a ton of cereal boxes, toilet paper rolls, and cardboard pieces you're saving for some art project. Try spray painting them gold or covering them with gesso next time and see what your child comes up with. You can also use gesso to cover used canvases from the thrift store, allowing you to use them again.

SETUP

"The setup" in process art is very important. Our goal is to create an inviting display of materials and tools that encourages wonder and intrigue. The setup does not need to be complicated. A simple setup can be beautiful and effective. Your setup is one way of telling your child you care about art making, you value creativity, and you are inviting them to do the same with you. In this book, you will see several examples of simple yet effective setups.

A Note about the Dreaded MESS

Nobody likes a mess. I get it. And some people associate art making with mess making. I promise you there are tons of activities in this book that will not be heavy in the mess department, and I've included some tips to handle the things that are a bit on the messy side.

I will say, the less stressed you are, the more fun and lighthearted the art making will be—and that's the goal. Following are some tips to handle the mess that I've found to be helpful. If any of the materials for invitations or projects in this book leave you seeing stars, don't use them. None of these experiences or materials is required. Process art is about the journey.

I'll be honest with you. Slime totally freaks me out. At different times I've completely banned it from our house, particularly after a leather couch incident I won't get into here. It took me a while to let slime back in, and now we have rules for it. Check out our Slime invitation (page 91) and you'll see what I mean. Rules are not the enemy of process art. Process art is not a total free-for-all. It can be guided and thoughtful and limitless in creativity, while still maintaining a calm, organized experience.

You know your child best. If your child tends to draw on the walls, take permanent markers off your material list for now. These experiences are meant to be light and fun. No one is judging you, and your kids will be so excited that you took the time to offer them something special. Trial and error is going to be a part of the journey.

Now, if you're particularly worried about the mess of a project or a mess in general, consider doing the project directly in a large shallow plastic bin (available at Target or similar retailers) or in a shallow cardboard box when possible. The mess will be contained in the bin. This is great, especially if your child is using glitter or paint. You can place a drop cloth under the bin for extra protection and even take it outside, weather permitting. I also encourage you not to work in a carpeted area whenever possible. If it's your only option, cover your area with a drop cloth or plastic tarp.

IF YOU'RE WORKING WITH PAINT
If you'll be offering paint, consider keeping a plastic bowl or tub of soapy water

continues >

nearby so kids can clean their brushes when they are finished, or at least have a place to put them and let them soak for easier cleaning later. When I worked as a preschool art teacher, I used a little song I learned from my friend, Rachelle Doorley, at Tinkerlab. It was a little chant that went "Dance, Dance, Dance" (as the kids gently moved the brushes in the soapy water), and then "Clean, Clean, Clean" (as the kids moved their fingers over the bristles to clean the brush). They chanted the little song over and over as they cleaned their brushes.

STORING PAINT

Baby jars are the perfect size for paints, easy to store in a drawer, and super easy to clean. Plus, they come with a lid. When we paint, we put a brush in each jar. I tell the kids that each brush has a "home" and shouldn't go in anyone else's "home." Our favorite brushes are the wood-handled multipacks from IKEA. Lids can loosely sit on top of the jars during storage. If screwed on tightly, the paints may cause the lid to stick to the jar.

USE A TRAY

Trays or place mats offer kids a contained workspace. You can get flat trays, round trays, cheap trays, fancy trays, IKEA trays, whatever you like. They will create the perfect little working area for tons of art activities. A tray can make art supplies look beautiful and inviting. Kids understand that what is on their tray is theirs to work with. (Great for siblings!)

A SIMPLE SETUP IS THE BEST SETUP

If you take the time to set something up when your children are not around—I'm talking 5 to 10 minutes tops—you may notice a great difference in your child's experience. A 5-minute setup the night before can set a great tone for the rest of the day.

SIGNS

Signs can be really helpful for different activities, especially Invitations to Create. Sometimes it's easier for children to follow directions or prompts from a sign than from a parent. I know for my own children, my little one especially, she does not want me telling her what to do. If a sign says, "Make a colorful card for grandma," she's all in, but if I say it, it's like "Uhhh . . . no."

GLUE

From the age of about two on up, kids can work wonders with a simple container of glue and a brush. Art and creativity don't have to be complicated. When kids are young, it's more about exposing them to new materials and honoring their process. We use a recycled clear container to store glue. There are a lot of projects that call for glue applied with a paintbrush. Soak the brushes right away in warm water and soap to prevent hard bristles.

WORKING WITH WATERCOLORS

When working with watercolors I like to give children two jars of water and a paper towel. This is a technique I learned from one of my favorite Los Angeles art teachers, Larry Garf. One jar is the designated dirty bath and one is the designated clean bath. The dirty bath is for removing the color on your brush after each color.

continues >

PLAY, MAKE, CREATE

14

For example, children can dip the dirty brush after using red paint, get all the paint off, and then test their brush on the paper towel. Rinse again in the dirty bath if it's not mostly clean. Then use the clean bath to get your brush ready for a new color. It will definitely take some time to get this down. Young children will likely end up with two dirty baths, but it's a great technique that they can master as they get older.

LIQUID WATERCOLORS

Liquid watercolors are one of my very favorite art materials. BUT, they are messy and definitely can temporarily stain hands and sometimes permanently stain clothes. I would call liquid watercolors an advanced art supply, in that you kind of need to know what you're doing with them and are able to work in an area where you're not going to be stressed out if paints spill or splatter. Outside is great, or a place where the floor is covered in case paints tip over. The beautiful thing about liquid watercolors is that the colors are incredibly vibrant, and because they're liquid, you can do all kinds of things with them, including one of our faves, using them with pipettes. See pages 39–40 for an example. If you're easily stressed with a mess, maybe hold off on these. If you are up for a beautiful challenge, go for it!

Food coloring and water can be used as a liquid watercolor substitution. These temporarily stain hands as well, and clothes, not so temporarily. You can use baby jars to store watercolor paints as well.

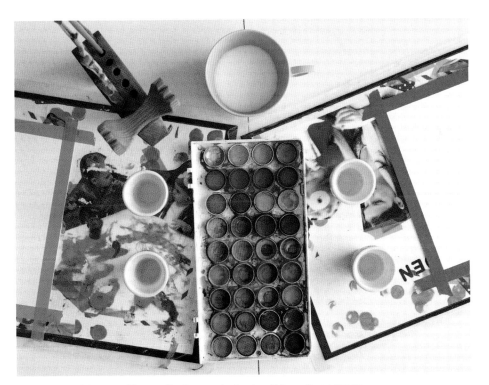

CHALLENGE: Make something smaller than an elephant and bigger than a mouse.

A GUIDE FOR PARENTS AND FACILITATORS

Pep Talk for Parents

If you are a parent, you are likely juggling five million things at once and possibly, on occasion, running around like a chicken without a head. I know this. I live this. Please think of me and this book as your cheerleader. We are on your side. In fact, we are cheering you on, chanting, "You can do this!" If you are new to process art and Invitations to Create, this could be a whole new, exciting chapter in your life. It could also be something you try once or twice this month and then decide your kids aren't ready, and you pick up this book again in six months. Nobody is judging you here. If your first invitation is a big ol' bust, so be it. That's life. If your second one gives you 30 minutes to make dinner or read your favorite magazine or sit by your child and create, then YES. We're all about it.

One thing this book is not is pressure for you to feel like you have to do one more thing to attain "perfect momhood" or "perfect dadhood." That doesn't exist. I am a parent just like you, trying to add value to my kids' life, to my own life, and to have fun in the process. I happen to be good at doing art with kids and coming up with ideas on how to do that. You might be an awesome cook or great at camping, or speak four languages. We all have our strengths. My intention here is to share what I'm good at and what has brought us joy and value, in hopes that you experience some of that same joy and value. And if anyone wants to give me a cooking lesson or show me how to pitch a tent, I'm open.

How to Talk to Kids about Art Making

This part is important. If you never do any projects from this book, but take away some of the language here, to me that's still a big win. The language we use with our children is as important as the making. After all, if our children work their hearts out on a self-portrait and we take one look and say, "What the heck is that?" we're definitely missing an important piece here. The language I use with children is about building relationships, confidence, and empathy. The following are phrases I have come to know and trust for twenty years. My own children have come to trust them and when I hear them using these words in their play or in conversations with others, it

brings joy to my heart. If this language is new to you, it might sound strange at first, but like anything else, it just takes practice. I'll use this language throughout the book to demonstrate how it might sound.

One way we use this language is rooted in these three simple phrases:

I wonder . . .
I notice . . .
I see . . .

These phrases set the tone for behavior and confidence. In other words, try getting in the habit of noticing out loud whatever behavior you'd like to see more of in your children. Think of yourself as a narrator of a great story your children are demonstrating. The more you narrate behaviors and attitudes you'd like to see more of, the more likely you are to see those things.

Other Effective Phrases

+ Keep going!
+ Tell me about that.
+ I notice you're really taking your time.
+ You've got really good ideas.
+ I see you're making really important decisions about your work.
+ I wonder what might happen if you keep going with that.
+ I can't wait to see what you'll do next.
+ I can see you're feeling really proud of your work.
+ Artists take their time to show they care about their work.

"Wow, I notice you're sitting so quietly concentrating on what you're doing. That's something artists do to show they care about their work."

Or . . .

"I see you're using pink for the windows of your house. I wonder what color you're going to choose next."

At first it may sound awkward, but you'll get the hang of it, and before you know it, your kids will be at the zoo and they will say something like, *"Mom, look, I notice that giraffe has such a big tongue. I wonder what giraffes like to eat?"*

Effective language helps us build inquisitive learners who ask important questions about the world around them.

FAQs

IS IT STILL PROCESS ART IF YOU HAVE A PLAN?

Absolutely! Process art does not mean free-for-all. I think this can be a pitfall for parents at times. I have a plan most of the time. I'm guiding and facilitating as we go. I'm just not saying, "This is what we're doing and this is how we're doing it." For example, if the idea is to make a house, you might have a bunch of materials out and a little card that says, "Let's make a house."

Along these lines, if your child wants to paint the walls, you're not interfering with their "process" by saying, "Um, no. We don't paint the walls." Boundaries create safety and security for kids, and they thrive in environments with clear and caring boundaries. There is nothing wrong with saying no to something you don't feel comfortable with.

WHAT DO I DO IF THINGS DON'T GO THE WAY I PLAN?

This is something I've struggled with as well. Sometimes I really want my girls to paint me these amazing black-and-white family portraits, and it's like they can sense it, sense my desire, my longing, my . . . pressure. Ha. Yes, I'm guilty. We all want these masterpieces for the wall to cherish forever. But you know what? It just doesn't always happen when we think it's going to happen. Sometimes the plan for a beautiful cardboard house turns into a saturated mush of brown watercolor paint, and that's okay. We've got days, months, years ahead of us to try and try again. We'll get that masterpiece. When we least expect it. I think, as parents, sometimes we've just got to give it up. Know what I mean?

WHAT DO I DO IF MY CHILD ALWAYS NEEDS HELP?
"I CAN'T. I NEED HELP."

This is a great question, and there are lots of ways to handle it. Some suggestions are to start with super simple Invitations to Create. Something like playdough and some sticks. The minute you see your child engaged, praise what you see. "I notice you're coming up with some really cool ways to use the playdough." "Oh wow, I've never thought of that." "I see you're working so well on your own." In this way, you're paving the way for what you want to see more of in the future. Whatever behavior you want to see more of, notice now. I also think that some parents interpret process art as completely hands-off for parents. I don't think that's true. It's great to help.

18

PLAY, MAKE, CREATE

It's great to sit down and work with your child. It's also a great switch to ask them to help you with something. "I'm having trouble cutting this. Maybe you can help me. You're really good with the scissors." Empathy is another great approach. If something is frustrating your child, you may say something like, "Hmm . . . those tapes can be so difficult sometimes. I see they keep getting tangled. That must be really frustrating."

WHAT IF MY CHILD IS FIXATED ON ONE PARTICULAR COLOR?

Embrace it. Likely it will shift. And, looking back, how much will you cherish their all-yellow family portraits? If you want to give it a shot, you can try, "I see you LOVE yellow. I can see why. Yellow is a fascinating color. When you're ready to explore some other colors, let me know and we can try some paint mixing." And then get back to embracing the yellow.

HOW DO I ENGAGE DIFFERENT AGES OF CHILDREN AT ONE TIME?

This is a popular question. I've tried to include many projects and Invitations to Create in this book that are great for multiple age groups. That's one of the very great aspects of process art. Because there isn't a predetermined outcome, the projects and process can meet each child at their developmental stage. A few examples are the small worlds (pages 77–79), big self-portraits (pages 73–74), and wands (pages 139–142). All of these activities can be done by most three-year-olds and older. And some can be done by a two-year-old who has assistance, especially the playdough invitation (pages 89–90) and the sensory activities. If you have older children and a very young child, you might consider putting out something sensory-based, like playdough, along with some of the more crafty activities. The big kids might end up playing with Oobleck while the little one makes a small world.

HELP! I HAVE A PERFECTIONIST CHILD.

Process art is excellent for perfectionists. There is freedom and relief in not having a prescribed outcome. Having said that, perfectionist tendencies can definitely show up. By practicing open-ended activities on a regular basis, children will begin to trust their instincts and ideas because you have created a safe and open space to explore. There are no wrong ways to do these activities. As you return to the language prescribed in this book, your child will begin to loosen up and take risks.

I also recommend activities that are totally open-ended, like the Invitations to Create, combined with a ton of empathy. "I can see it feels really hard for you right now. You really want your work to look a certain way. I hear you." When you do see your child taking risks, praise them. "I see you're really taking a chance here. Good for you." "Take your time. I know you'll get it. I believe in you." Try to avoid hovering and doing things for them. That might feed the need to do things "perfectly." I also try to avoid the word "perfect" when talking with children.

Tips and Best Practices

WORKING WITH COLOR

Sometimes manipulating color choices can add interest, beauty, and depth to a process. We often stay away from darker colors like brown and black. Sometimes we only give pink, oranges, yellows, and white as options for a particular project. You could also simplify a project by just doing it in one color, like yellow, or just a black permanent marker. Experimenting with color choices is often the best way to experience the masterpiece you're hoping for.

COLLABORATIVE ART AND CONNECTION

Sometimes it's really nice to just sit down with your child and do a painting, sculpture, or drawing together. How about this time you let your child make all the decisions, and you ask a lot of questions while following their lead? You can say things like, "Where should I paint? What color should I use? Is this right? I really like the lines you're making over there. Can you show me how to do that? It's really nice creating with you. I wonder what you're going to paint next. I notice you're really concentrating while you're working. This is fun! Thanks for spending this time with me. I really enjoyed it."

DISPLAYING YOUR CHILD'S ARTWORK

I can't stress enough the importance of displaying children's artwork. When you hang your child's art you are saying, "Your work is important to me. It has value. I am proud of what you are doing." Plus, there are so many great ways to hang artwork. You can do an art wall. You can get this great wire contraption from IKEA. Or just hang a string from some nails and use clothespins to hang up your child's art. It's all great.

This curtain wire from IKEA is perfect for displaying artwork. It easily mounts to the wall or ceiling, and you can quickly change out the displayed artwork.

ART DOESN'T HAVE TO BE FANCY

In the end, kids just want to spend quality time with us. Get a piece of over-sized paper and a watercolor set or washi tape and have some fun. Next time a package comes in the mail, turn it into a family mailbox. Whatever you decide to do and whatever pace you go, just enjoy the process. I think my daughter, Gigi, said it best when she said, "Mama, I don't really care what you set up, I just like knowing you thought about us."

A FINAL NOTE TO PARENTS

Do the best you can. It doesn't have to be perfect. You can do this!

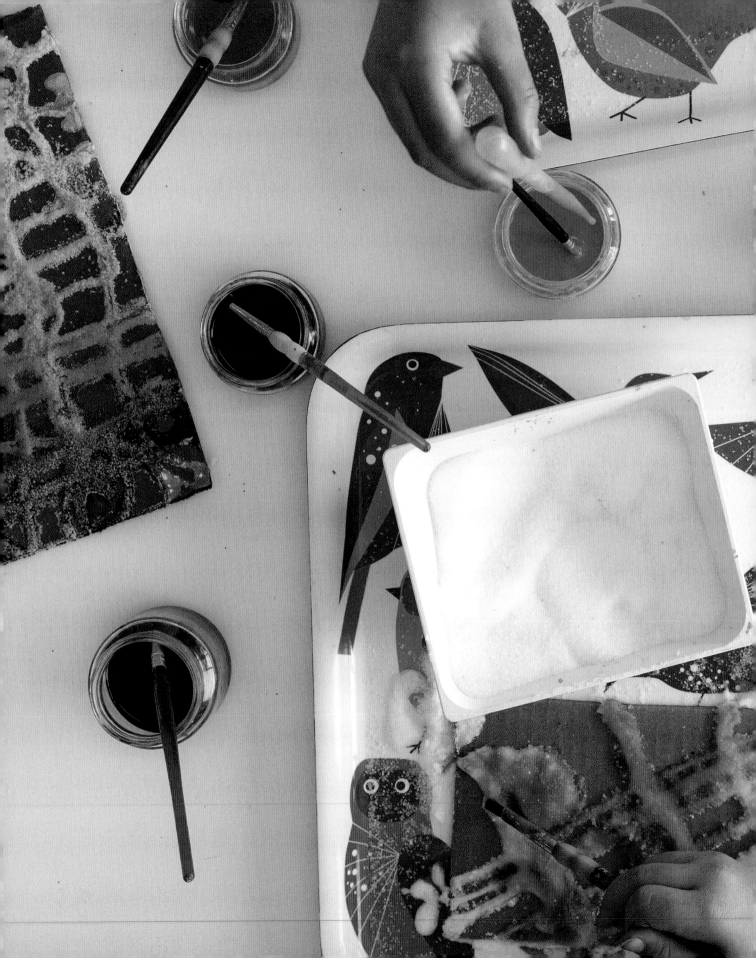

Chapter 2

INVITATIONS TO EXPLORE
EASY IDEAS FOR FUN AND PLAY

Okay, here we go. We're going to start with Invitations to Explore. These are process-based activities that are more about exploring the materials than anything else. I encourage you to let go of any expectations and start with an invitation that sounds easy or appealing to you. Concentrate on your simple, yet inviting setup, and let the kids do the rest. Feel free to sit down with them and participate or simply observe.

If this is the first invitation you've ever set up, your children might be bewildered at first. You might want to take a moment to set the tone and expectations for invitations.

It might sound something like this:

"I set up something special for you this morning. I'm excited to share it with you. If you are excited about it, you can show me by using the materials carefully and slowly while you explore. I think you're going to like it. When we're done, we can take a moment to clean up and you can tell me if you'd like me to set something up for you again another time."

Or you might walk over to your set-up table with your children and say, *"Wow, look at this. I wonder what you are going to do with all these materials. This looks like fun."* You know your child best.

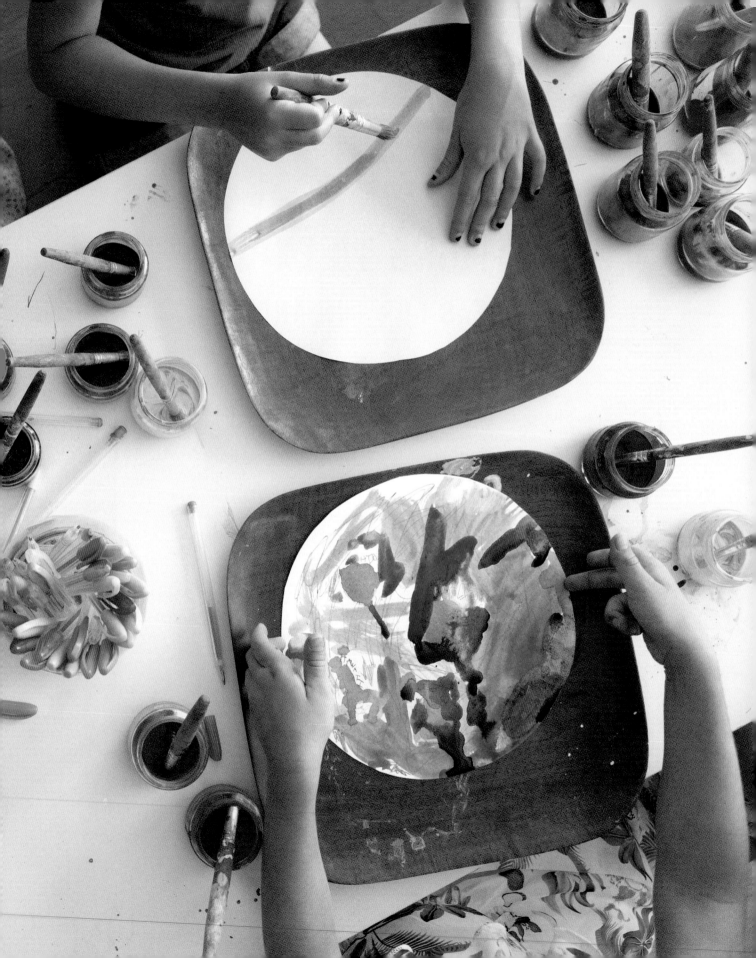

Your World

Materials

sturdy white watercolor paper

oil pastels, markers, or gel pens

watercolor paints and brushes (Whatever you have is great. We used liquid watercolors.)

paper towel to slurp up extra watercolor

Create world after world with this super-simple and satisfying invitation. Give your child a circle of paper and see what kind of world they want to create. Sometimes just changing the shape of your paper makes a big difference. Have several circles on hand so they can make as many fantastical worlds as they'd like.

Pro Art Tip

If the oil pastel isn't spreading smoothly on the paper, you may need to warm up the stick. Holding it in your hand for a few moments should do the trick.

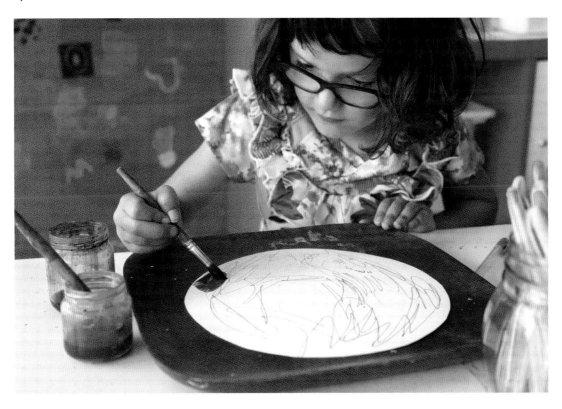

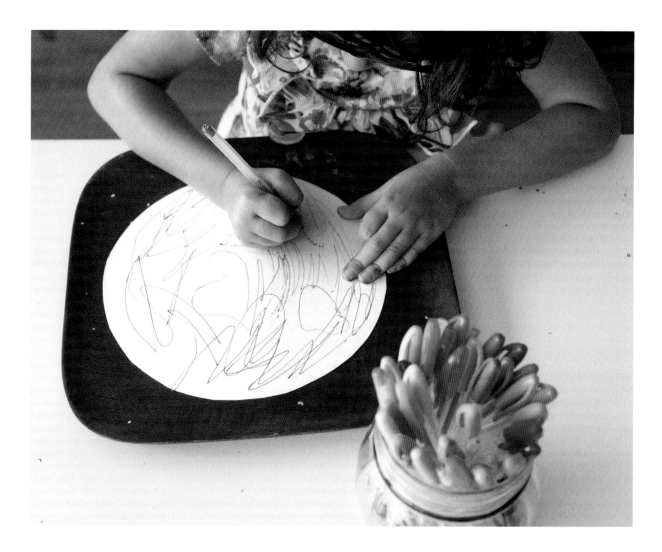

PROCESS Cut a circle out of sturdy white watercolor paper, about 8 inches (20.3 cm) in diameter. Set up oil pastels or gel pens and watercolor paints and brushes for art making, and encourage your child to create their own world.

There's no right or wrong way to create a world. Your child might want to combine pen and paint, or they may want to use only pen or only paint. If you have more than one child, they might even enjoy creating a world together.

Art Technique Tip

Experiment with using pen underneath and on top of paint layers. Just be sure to allow the paint to fully dry before drawing on top with pen. Oil pastels can go under or on top, and you don't have to wait for the paint to dry.

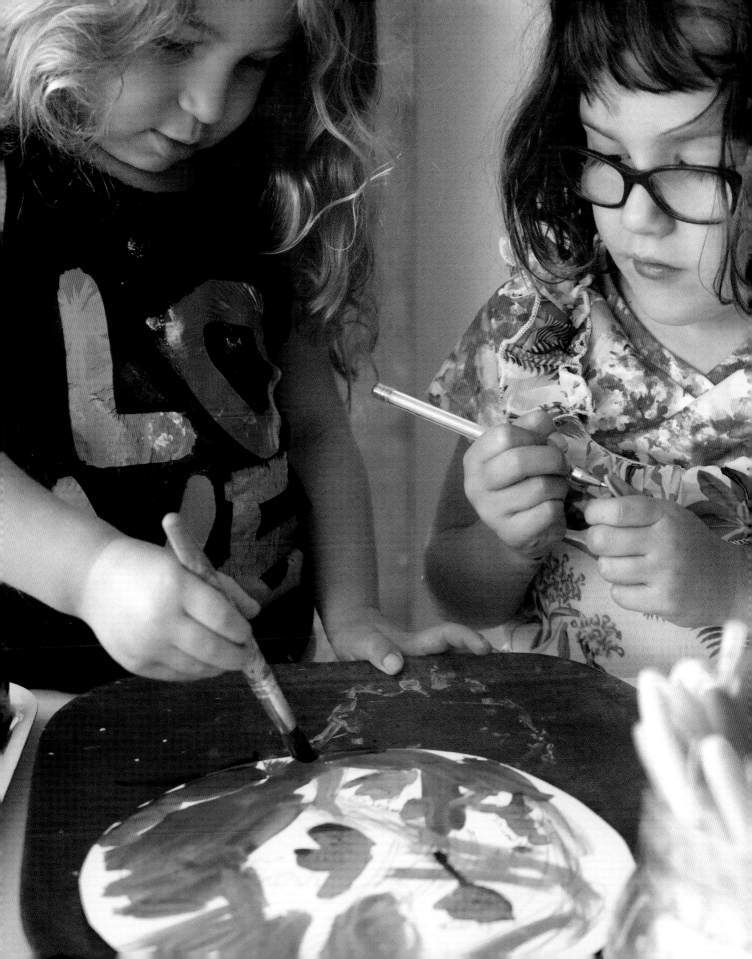

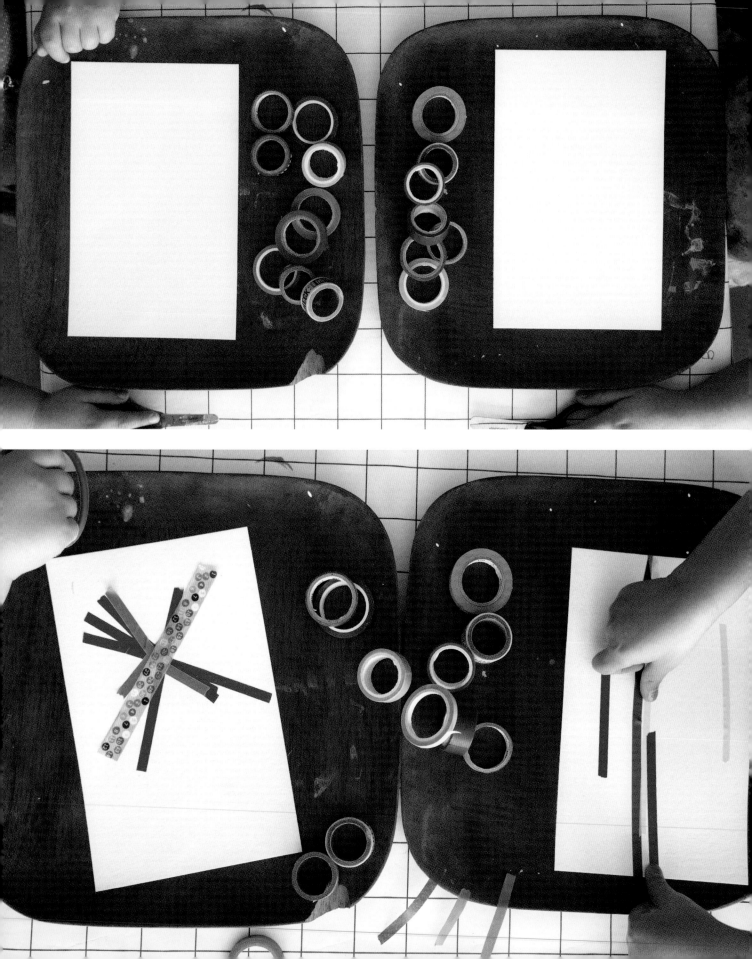

Tape Collage

Materials

washi tape rolls

blunt kid's scissors

sturdy white paper

Pro Art Tip
This invitation can be extended using paints, permanent markers, gel pens, etc.

Learning to use scissors takes time. My children have had scissors in their hands since about age two. I know that may cause alarm for some, but I trusted that my child could handle it while sitting next to an adult. Please use your own discretion, but in my professional opinion, most three-year-olds are more than capable of using scissors designed for children. By the time they get to kindergarten they'll be cutting champions.

Tape is a great way to get kids to practice using those scissors. They can let the tape out a few inches on their own, let the roll hang, and then snip the end. Another method is to stick the end of the tape to the table, stretch out the roll a little bit, and cut. I learned that from a four-year-old, by the way. Other simple invitations for practicing with scissors include: scissors and playdough (see our favorite playdough recipe on page 89), flowers (see the invitation on page 121), foam paper, or yarn.

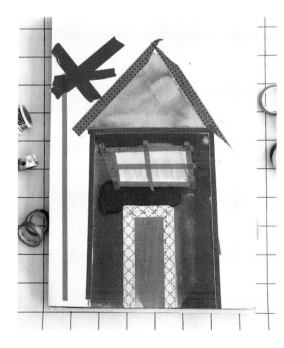

PROCESS Set out a piece of sturdy white paper, blunt kid's scissors, and as many rolls of washi tape as you'd like. Invite your child to create their own collage or design on the paper with strips and pieces of washi tape, using the scissors to cut the tape.

Most washi tape also tears easily. If you're not comfortable with your child using scissors, they can still explore this invitation to create by simply tearing pieces of tape for their collage.

"Look at that. I can see you're really getting the hang of this."

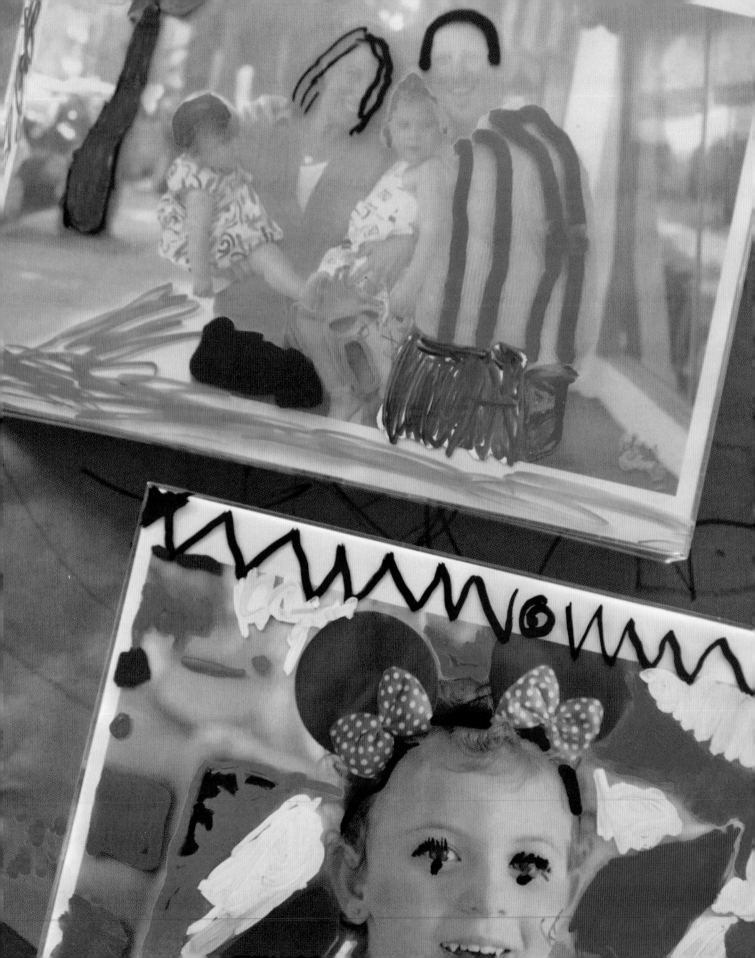

Paint Your Family Photos

Materials

family photo

plastic frame

chalk markers

paper towels

Pro Art Tip
If you don't have plastic frames, plastic sleeves will also work.

Have fun painting your family photos. Place them in a clear plastic frame, and kids can use their imaginations to create backgrounds, costumes, accessories, and whatever else they can dream up. You can print out a few photos and have them ready to swap out when the first one is finished. Kids can easily wipe off the chalk marker with a paper towel to start over.

PROCESS

Place a family photo in the clear plastic frame. The children can doodle and draw on the frame with chalk markers. When they want to start over or draw on a different family photo, they can simply wipe away the chalk marker with a paper towel.

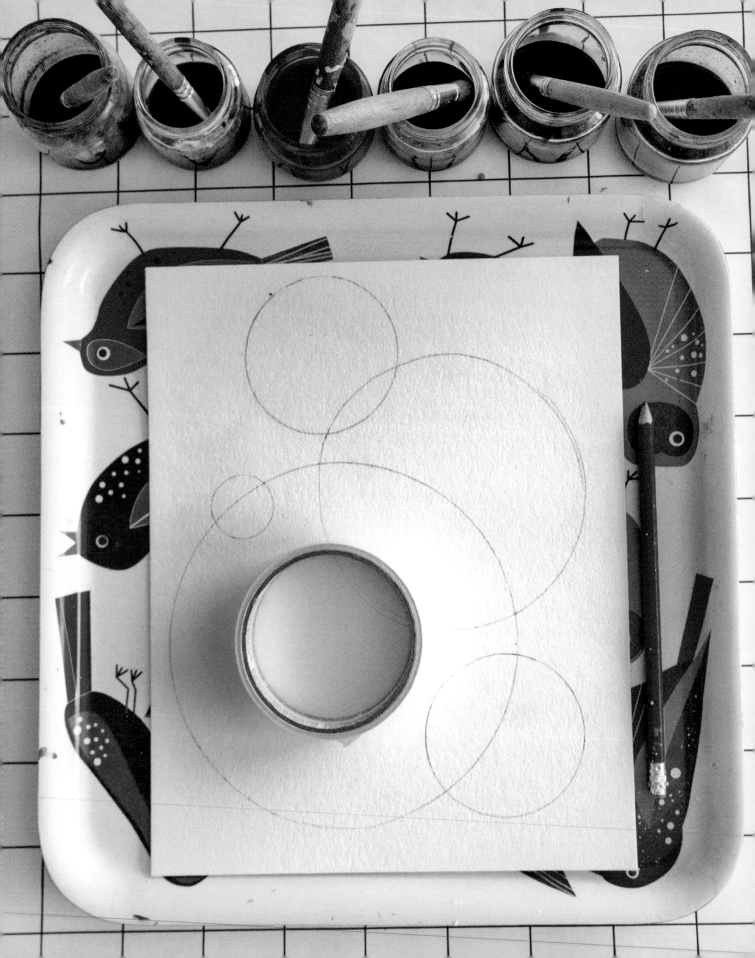

Bleeding Circle Paintings

Materials

circular objects

pencil for tracing circle shapes

sturdy white paper

liquid watercolors in jars (food coloring works as well)

brushes in all the jars

Kids can have fun finding different circle objects around the house to trace on a piece of paper, creating a collage of circles. Parents can help with this part or do it ahead of time. Adding color with liquid watercolors creates a mesmerizing effect.

PROCESS Find circular objects, such as bowls, plates, and tape holders, around the house. Use a pencil to trace the objects on a piece of paper, creating a collage of circles. Then invite your child to paint in the circles with liquid watercolors and watch how the colors bleed from circle to circle.

Pro Art Tip
Liquid watercolors are one of the more "advanced" art supplies we use for invitations. If the mess worries you, save this one for outside or use a watercolor palette instead. No big deal.

33

Cotton Swab "Oil Paintings"

Materials

sturdy white paper

oil pastels

cotton swabs

any kind of cooking oil

Oil pastels are often a new and engaging drawing tool for kids. They have an oil base, which makes them glide smoothly on different surfaces. Kids will definitely be curious about the cotton swabs and oil waiting nearby for this invitation. Invite them to try using a cotton swab dipped in oil as a special paintbrush. The oil turns the pastels into paint, creating a wonderful effect on the paper.

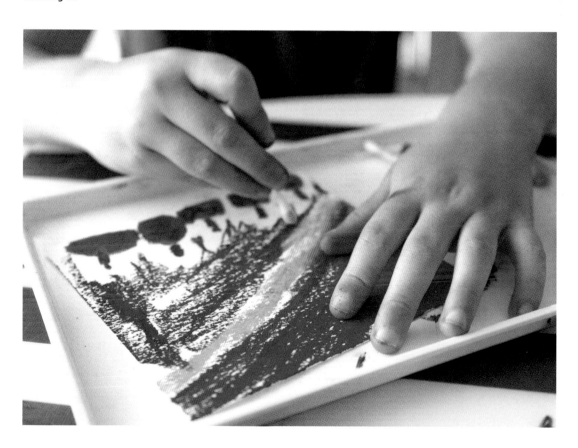

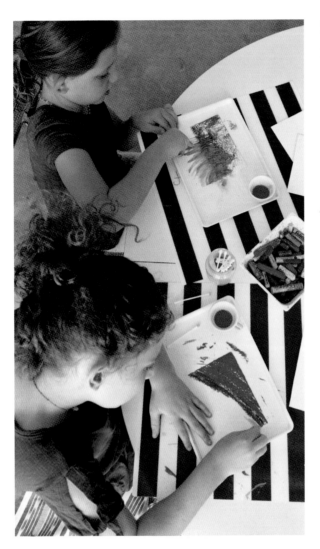

PROCESS

Cut up a few pieces of your favorite sturdy paper into cards (about 4 x 6 inches [10 x 15 cm]) and invite your child to make their favorite designs and drawings on the cards with oil pastels. Encourage them to use a cotton swab dipped in cooking oil as a special paintbrush to turn their drawing into a painting.

"Whoa! The oil makes the pastels like paint!"

Pro Art Tip

I like to tell kids that oil pastels and watercolors are enemies. You can try adding watercolors over your painting. The oil pastels will say, "Get off me! You can't cover me."

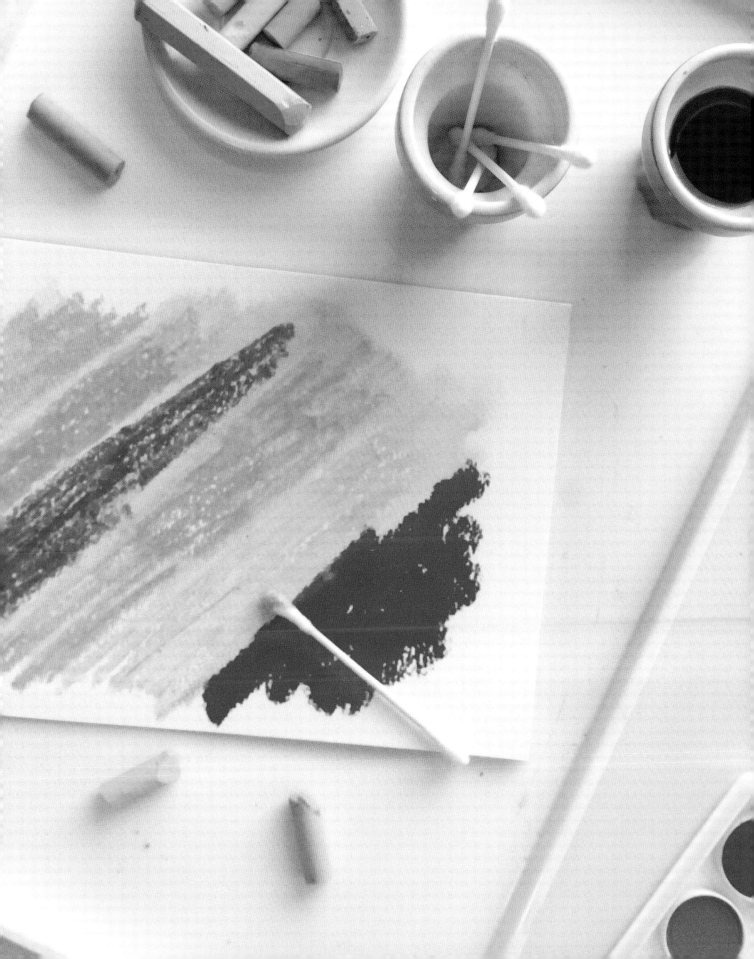

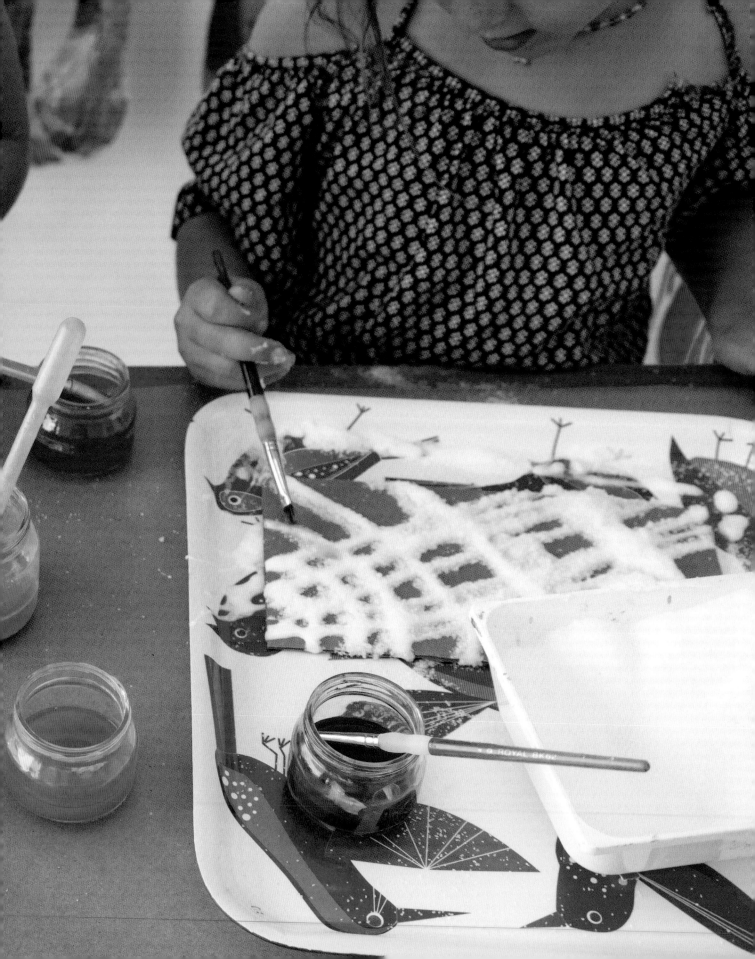

Salt Painting

Materials

white glue in a
squeeze bottle

few pieces of
cardboard or
thick paper

salt in a bowl

pipettes or
a small brush

liquid watercolors
in jars (food coloring
works too)

Salt painting is an activity we return to over and over again. Salt allows the watercolors to travel and mix, magically turning ordinary white glue drawings into colorful designs. It's a great process for multiple ages and meets children where they are developmentally. It may take a little practice, but each child (and adult) will get the hang of it.

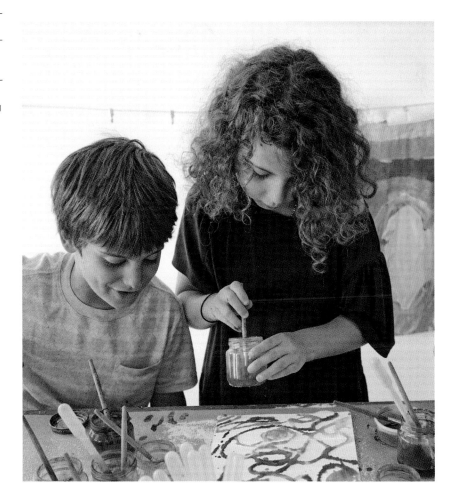

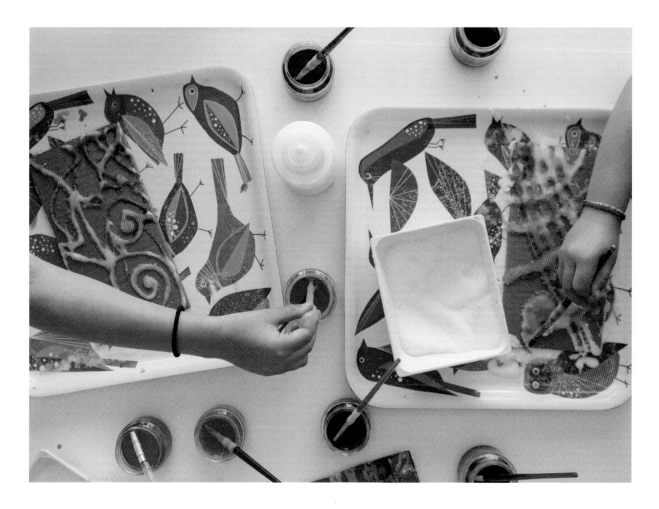

PROCESS

Gently squeeze white glue over a piece of cardboard or thick paper, as if you are creating a spiderweb. Do your best to avoid big puddles of glue. This may take practice for the younger ones.

Sprinkle salt over your spiderweb until all the glue is covered. Tap the extra salt back into the salt bowl to use again.

Using your pipette, drop small drops of liquid watercolor over different parts of your spiderweb. Watch as the color travels and mixes along the salt paths. This can be done over and over again.

Art Technique Tip
Change it up by using small brushes for the watercolors instead of pipettes to slow down the process. Which method do you prefer?

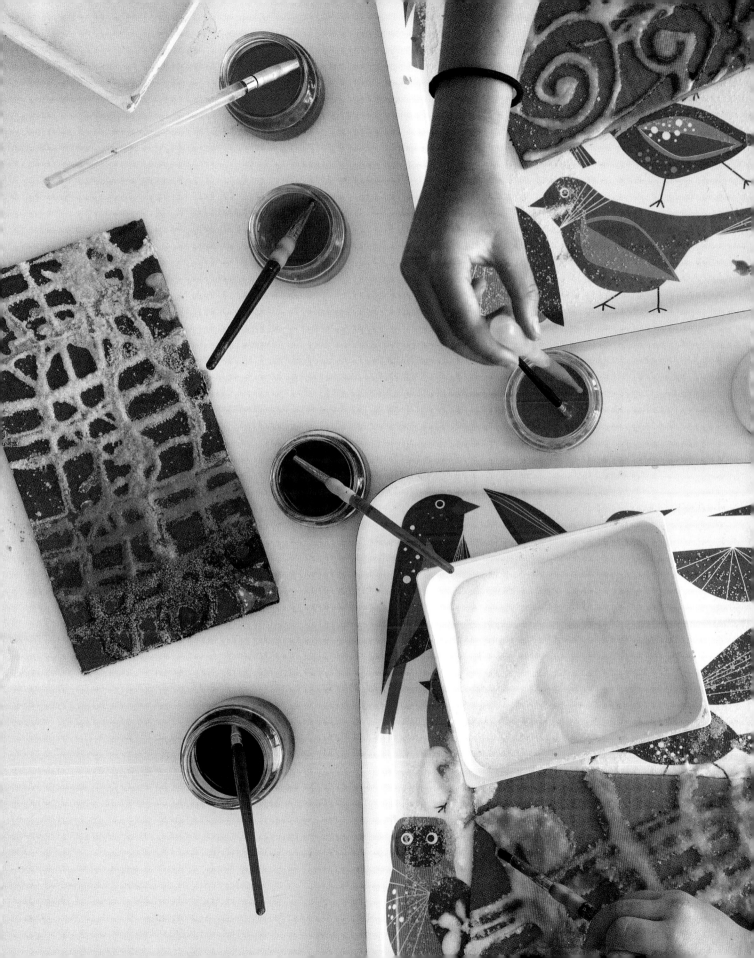

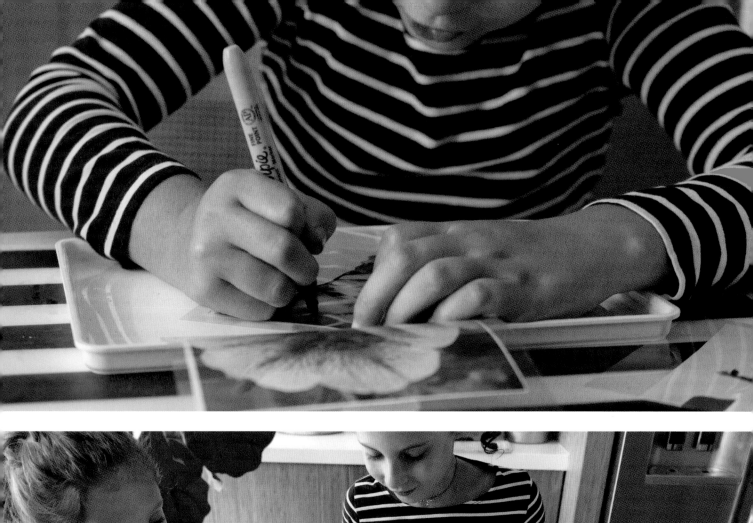
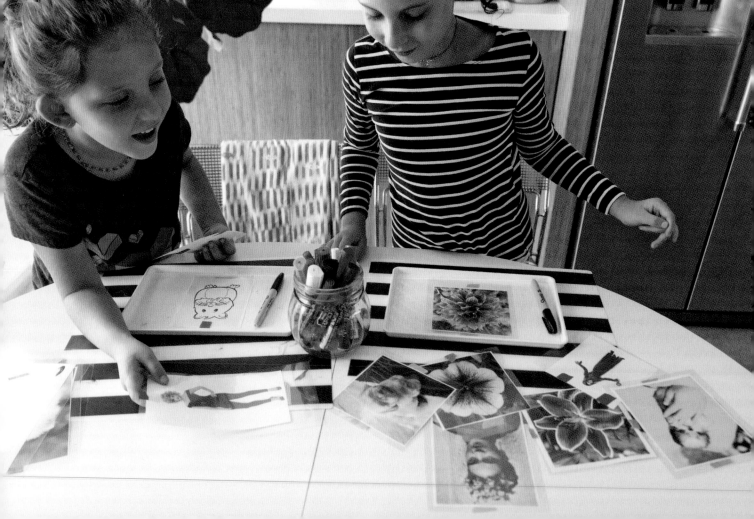

Trace Your Faves

Materials

tape

printouts of child's interests

transparency film sheets

permanent markers

chalk markers (optional)

Every child has different interests. Print out a few of your child's favorite characters, foods, flowers, or places, and invite them to make their own traced versions. You can even print out pictures of your child! Just tape a piece of transparency paper directly over each printout and you'll be ready to go.

PROCESS

Use tape to attach each printout of your child's favorite things to a sheet of clear transparency film. Set out an assortment of both regular and fine-tipped permanent markers (or chalk markers) in an array of colors. Invite your child to doodle and draw on the transparency film to add bright colors, designs, and embellishments to the photos, and watch their imaginations take flight.

"Mama, look!
It's a little puppy!
Oh my gosh.
I'm doing her first."
—Diana, age 5

"I'm doing the flower.
It's so beautiful."
—Gigi, age 7

Pro Art Tip
The doodled transparency sheets can become fun and whimsical stand-alone works of art.

Diana озеб

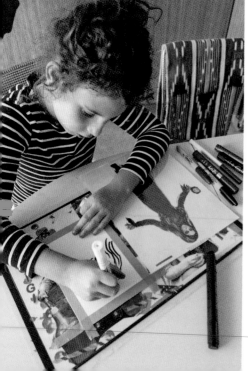

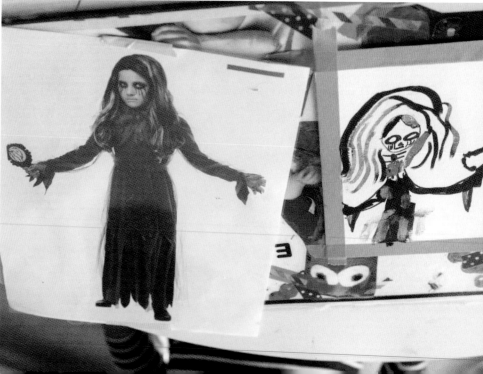

Draw What You See

Materials

object or
photograph
of interest

black permanent
marker

sturdy white paper

paints or markers
(optional)

Many skills can be learned from observational drawing. For example, children will learn to pay attention to detail, recognize shapes, improve their fine motor abilities, and build confidence. I recommend starting with very basic objects to draw, like round fruits or a simple flower, and build up to more organic and interesting shapes as your child gets older and more confident. I also recommend staying away from pencils and erasers. Perfectionist children will spend more time erasing than drawing. Observational drawing takes practice. The best way to prompt an observational drawing is to say, "Draw what you see." You can help your child identify basic shapes in just about anything.

PROCESS Set out an object or photograph for your child to draw. Invite them to draw what they see using a permanent marker instead of pencil. You might help them study the object to identify shapes and lines to draw.

After the initial drawing, children can decide if they want to paint or color their drawing.

> **Pro Art Tip**
> *If you don't know what to say when you see your child struggling, try practicing empathy: "I can see it feels really hard for you right now. You really want your work to look a certain way and it's really hard to do it the way you want. I understand."*

Draw What You Don't See

Materials

few pieces of white printer paper

marker

blindfold (optional)

Pro Art Tip

When you see your child taking a healthy risk, encourage them: "I see you're really taking a risk here. Before you didn't want to try this, and now you're doing it!"

This is a super fun invitation that can lead to a lot of giggles. It's easy for kids to spend time and effort on a drawing, but what happens when they draw with their eyes closed? For this invitation, you may want to prepare a few basic cards with the words of simple objects on them, like "car," "smiley face," "a piece of popcorn," etc. Or you can just think some up on the spot.

PROCESS Let your child know you have a super silly challenge for them: You're going to read an object from one of the cards, and they are going to try to draw it with their eyes closed. You might opt to use a blindfold to ensure there's no peeking.

Enjoy all the drawings that evolve. After, kids can add details with their eyes open if they'd like.

47

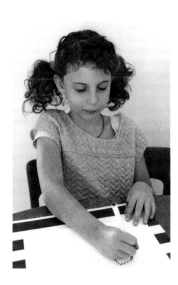

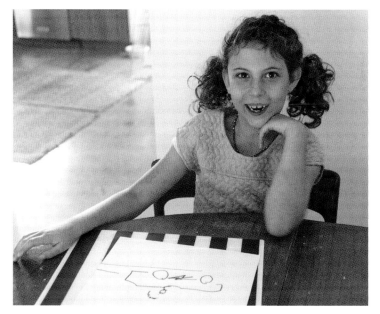

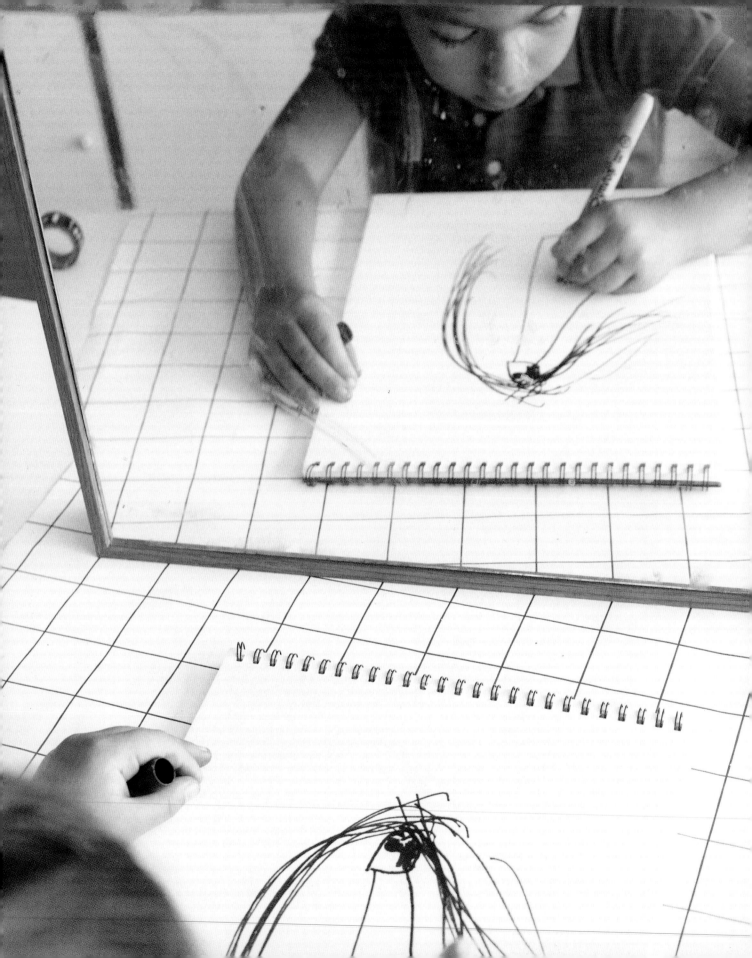

Self-Portraits in the Mirror

Materials

mirror (We found this one at our local dollar store.)

black permanent marker

sturdy white paper

Pro Art Tip

When I'm drawing in front of my children, I often use my nondominant hand to even the playing field a little bit. After all, "Comparison is the thief of joy." —Theodore Roosevelt

I love a good self-portrait. Watching your child gaze into a mirror and draw what they see at different ages and developmental phases is mesmerizing. You can even do your own self-portrait alongside your child. See page 73 for an extension of this self-portrait activity.

PROCESS Set up any mirror you have around the house at a table or desk and catch a glimpse of your child's reflection. You can talk about the shapes you see first, pointing out circles and lines. Invite them to draw their self-portrait with a permanent marker.

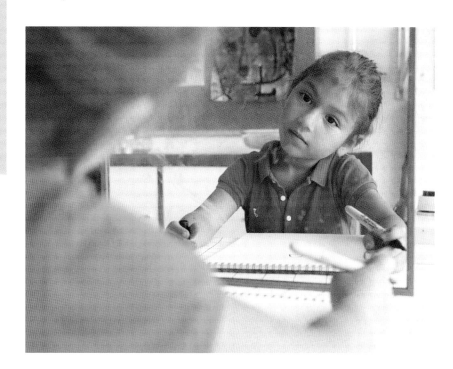

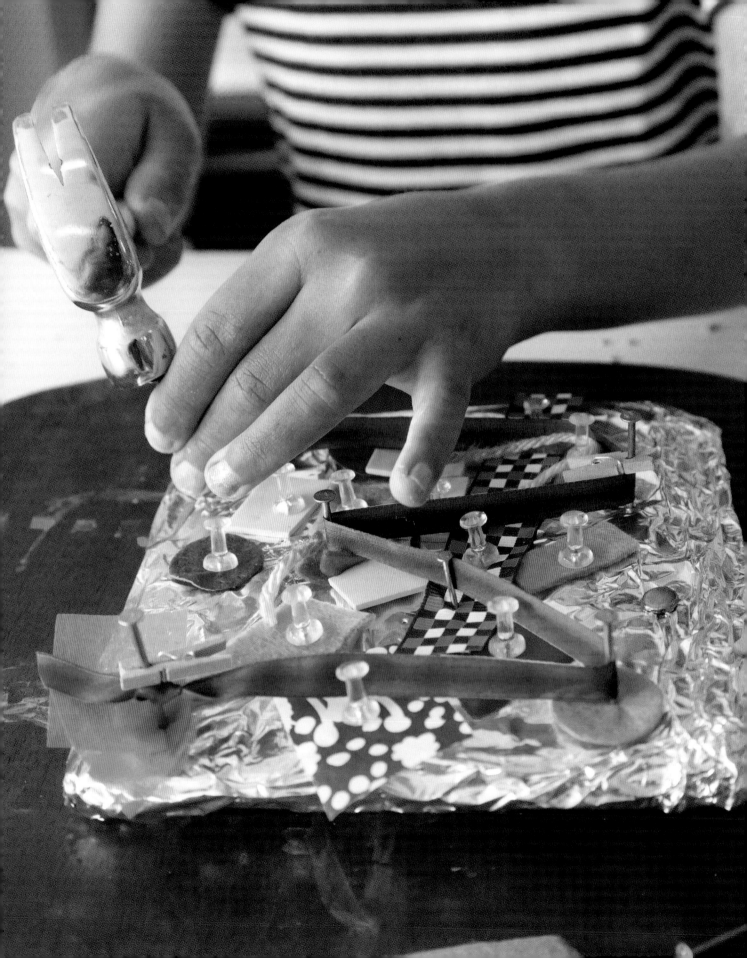

Hammer Time

Materials

hammer

nails

thick cardboard or stacked cardboard wrapped in tinfoil (Make sure your stack is taller than the length of your nails.)

thumbtacks

string

cut paper or felt (optional)

Pro Art Tip

If you don't want to use a hammer, kids can use thumbtacks or nails to puncture the cardboard.

This invitation is a great stepping-stone to Crazy Contraptions on page 133. You'll see and read throughout this book that I am a firm believer in giving kids real tools to work with in a supervised, safe environment. Hammers are a great tool to build hand-eye coordination, gross and fine motor skills, and confidence—and to blow off steam. It is exciting to work with a hammer. It feels really grown-up and sends a message to our children that we believe they are capable human beings. Please use your own discretion to decide if your child is ready to use a hammer safely. In this invitation, we've paired hammers with cardboard as an easy base to puncture, leading to happy success for your child.

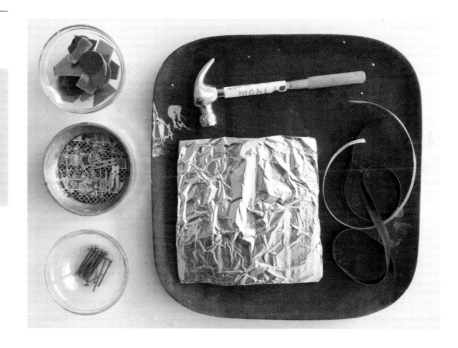

PROCESS

Demonstrate how to safely hold a hammer and explain all your safety rules, like always looking at what you are doing, using the hammer only while sitting, and never using it to hurt. In my experience, kids intuitively understand how to use the hammer and nails. You can help as needed. The thumbtacks will easily puncture the tinfoil and cardboard, and children can use the string to wrap in between the nails and tacks. They can stick cut paper or felt under the thumbtacks to secure.

Join the Fun

No one said you can't sit right down with your child and work alongside them. In fact, my girls stay engaged twice as long when I participate with them. At the end of the day, kids really just want our time and attention.

How about for this invitation, you sit right down with them and start hammering in those little nails and thumbtacks. You'll be modeling great behavior and creative interest, and sometimes that's all it takes to make a big impact on your child. You may even want to ask them to show you how to use the hammer. *"I see you're so good at using the hammer. Can you show me? How do I get these little pins in here? Oh, thank you. I asked the right person to show me this."*

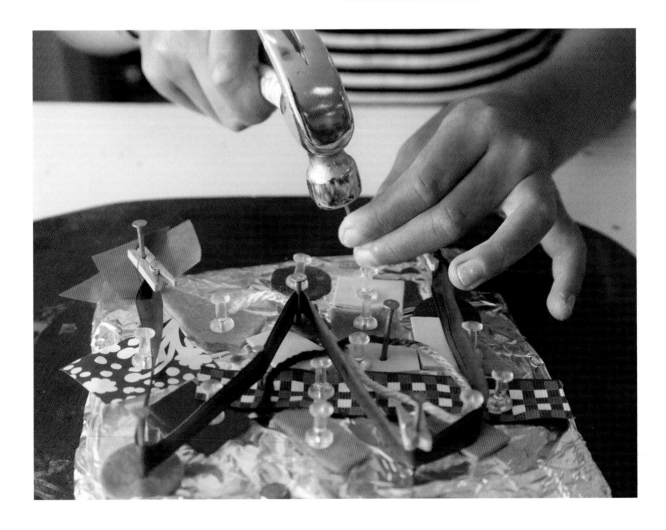

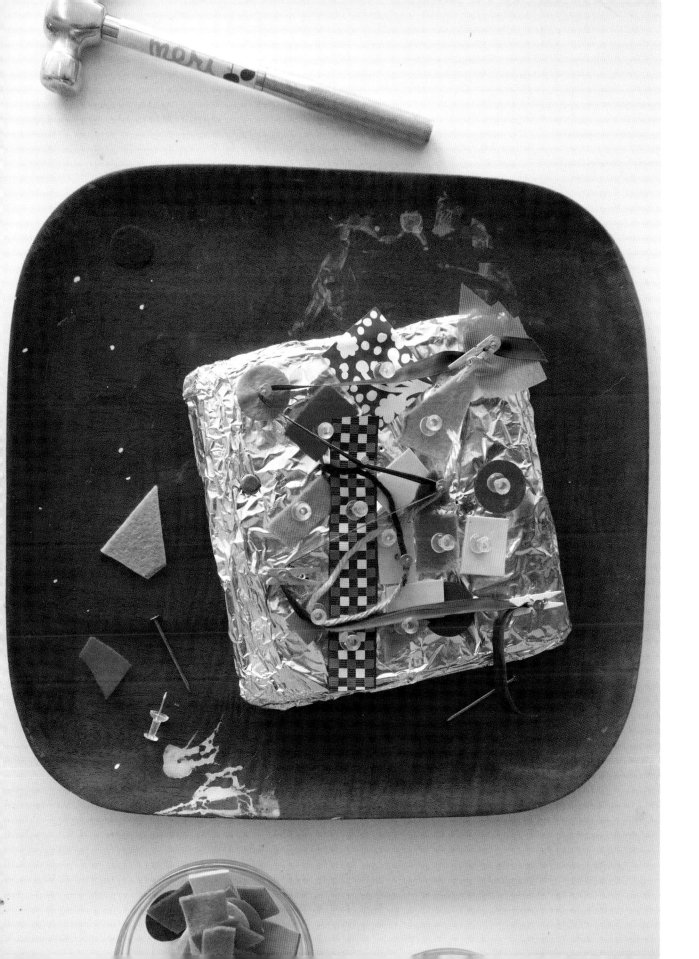

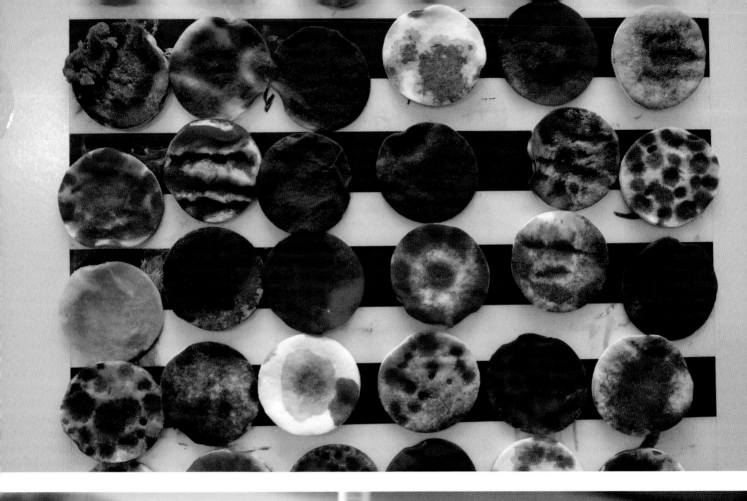

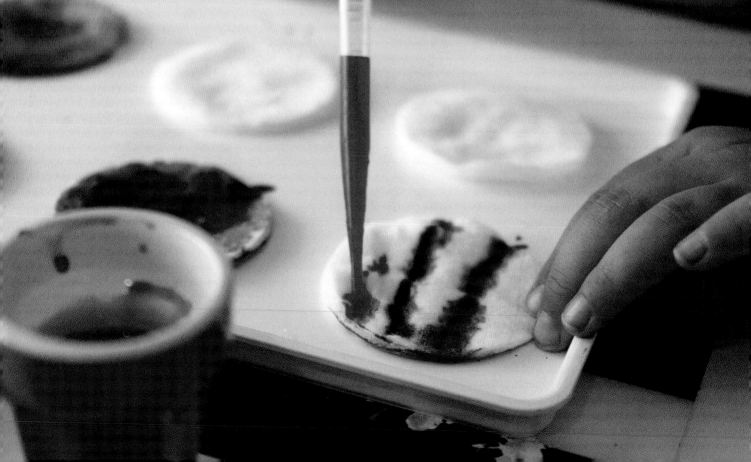

Paint What?!

Materials

liquid watercolors or food coloring mixed with water in the primary colors (blue, red, and yellow)

cups or containers to hold the color

pipettes for each color

cotton rounds

Pro Art Tip

Extend this activity by saving your mini artworks and inviting your child to come up with something fun to do with them for your next invitation. Maybe you can create a little doll, use them on a sticky mural (see page 97), or make a collage? I bet your child can think of some pretty great ideas.

One of the fun things about invitations and process art in general is that there are no rules. You can discover all kinds of interesting ways to do things, like turning ordinary cotton rounds into tiny round watercolor masterpieces. In this invitation, kids explore with liquid watercolors (or food coloring and water) in the primary colors, leading to all kinds of discoveries and creativity. The paints will mix on the cotton surface, turning into brand-new colors, which makes this a great activity for learning basic color theory.

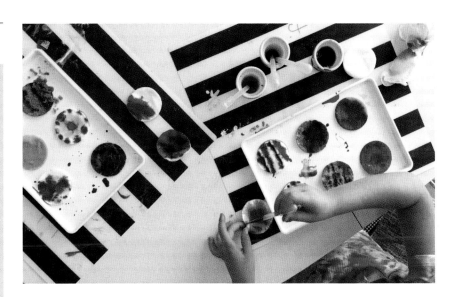

PROCESS Set out the three primary colors (blue, red, and yellow) and a pipette for each color. Arrange cotton rounds on a tray or other work surface. Children can use the pipettes to drop color onto the cotton pads. The liquid watercolors will feather and bleed a bit. Encourage your child to experiment by combining the three primary colors in different ways to create new colors.

Chapter 3

INVITATIONS TO CREATE

OPEN-ENDED, CRAFT-BASED ACTIVITIES

Invitations to Create are simple art activities that may have a more specific outcome. Each child's outcome will be different, but the activities are a bit more guided. Having said that, sometimes invitations take on a life of their own and end up going in a completely different direction than intended. I encourage you to let them unfold naturally and enjoy the ones that are a great fit for your child.

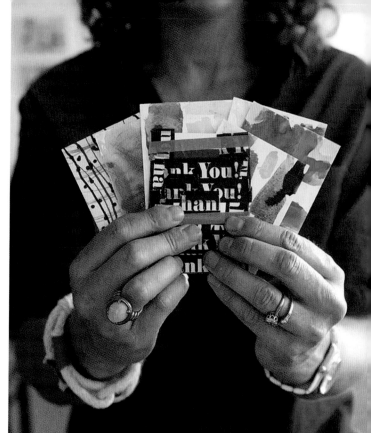
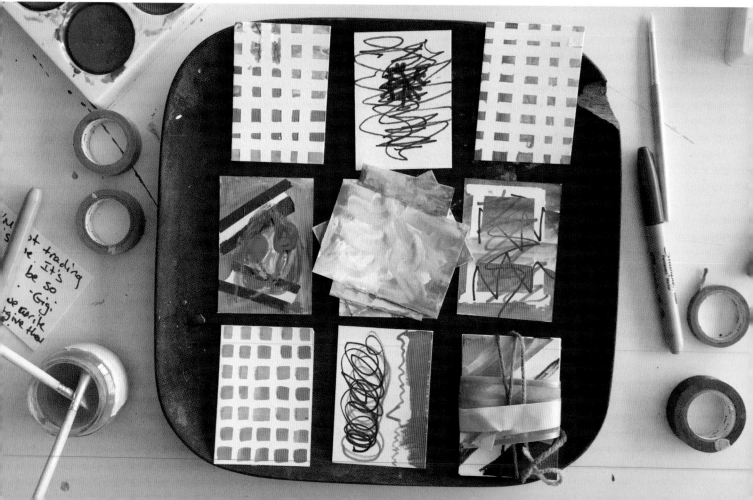

Artist Trading Cards

Materials

watercolor paper cut into rectangles (2½ x 3½ inches [6.5 x 9 cm])

markers

washi tape

watercolor paint

other decorative elements, such as stickers, gel pens, sequins, oil pastels, etc.

Artist trading cards (ATCs) are small works of art that can be created, collected, and traded. The possibilities for decorating them are endless. The only rule is they have to be 2½ x 3½ inches (6.5 x 9 cm).

Check out how this invitation evolved into a heartfelt community experience on page 156. You never know where the magic of process art will lead you.

Art Technique Tip
Learn how to use tape as a resist: Place tape in a pattern, draw or paint over it, and then pull it off to reveal a design.

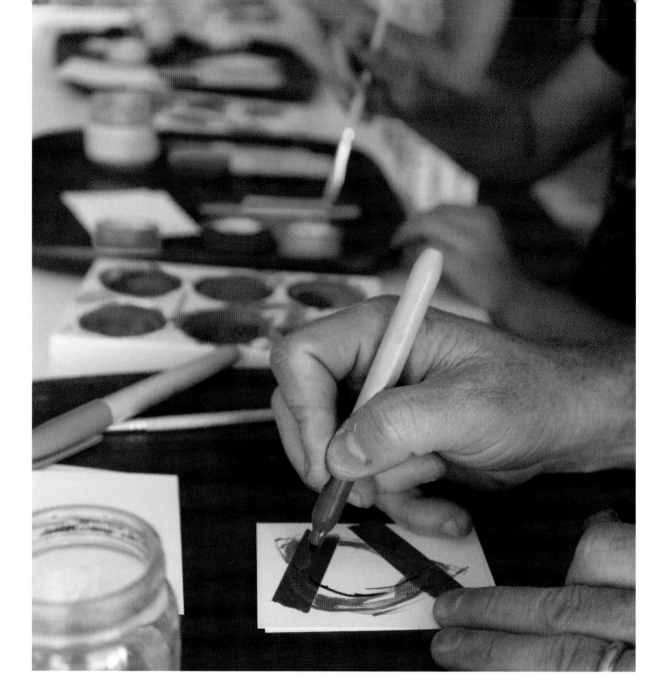

Pro Art Tip

Artist trading cards were started by Swiss artist M. Vänçi Stirnemann in 1997. There are Artist Trading Card, or "ATC," swaps all around the world.

PROCESS

Invite your child to make as many cards as they want. They are fun to make in multiples or in collections with different themes. There are no rules here. Children can use all of the art supplies to design and decorate their cards however they wish.

You can pop them in the mail for a friend in another part of the world and get some in return. Keep them as a creative collection or hand them out to friends.

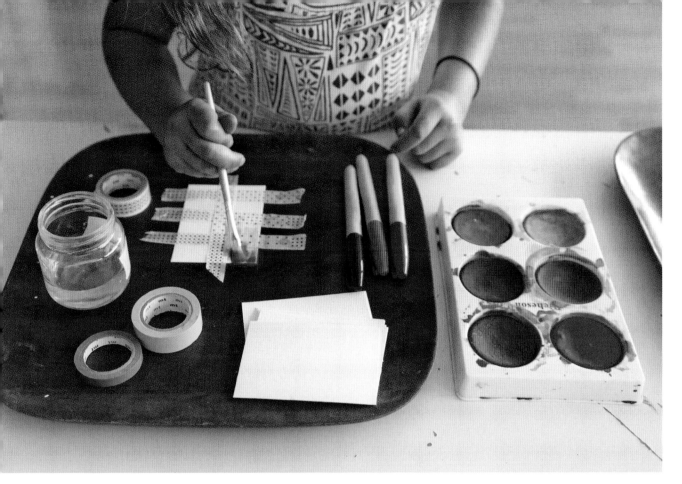

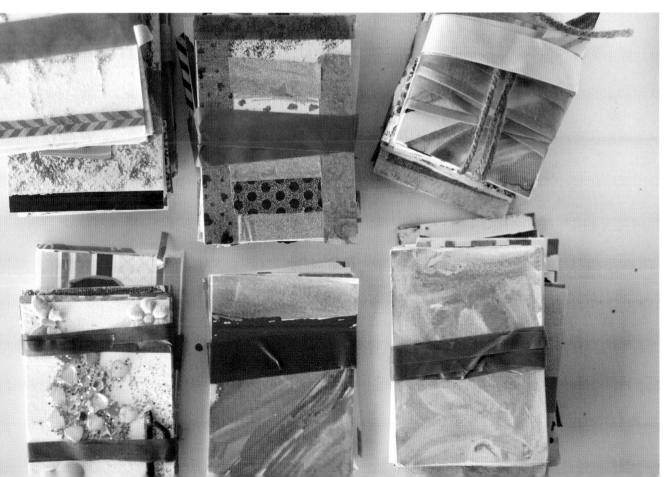

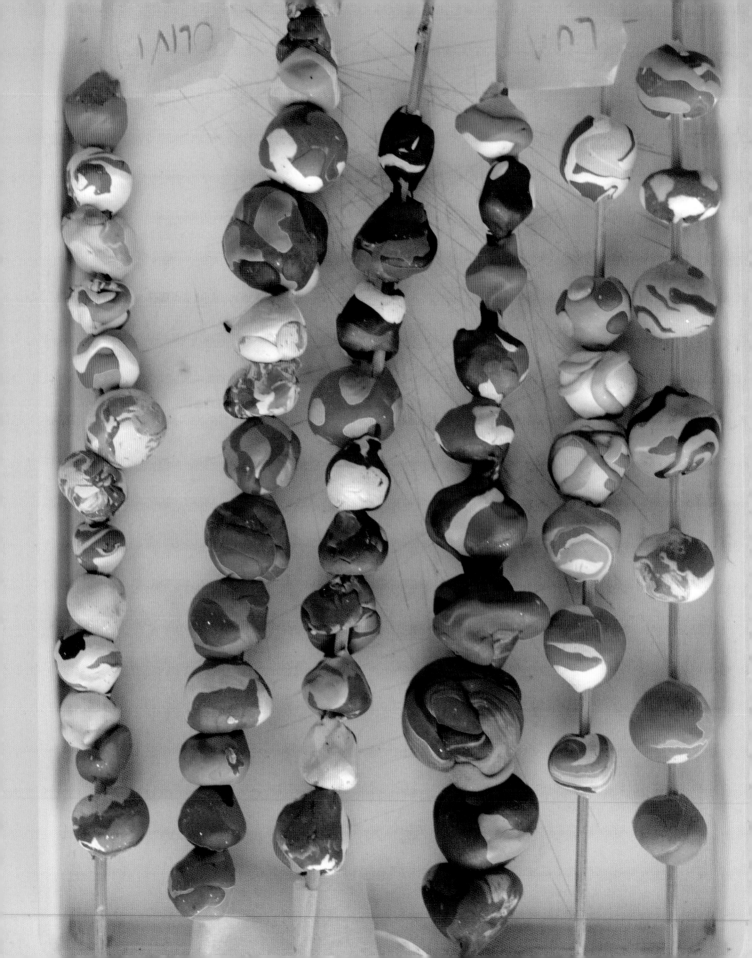

<p>INVITATION TO CREATE</p>

Clay Beads

Materials

polymer clay

skewer

oven or toaster oven
for baking your clay

string, cord, or yarn

Working with polymer clay is an addicting activity that can be explored in many fun ways. One great way to get started with polymer clay is by making beads. There are endless ways to make beads. Explore our suggestions and designs, and experiment with your own. Polymer clay remains soft until baked. When your child is done making their beads, just follow the manufacturer's instructions on the package.

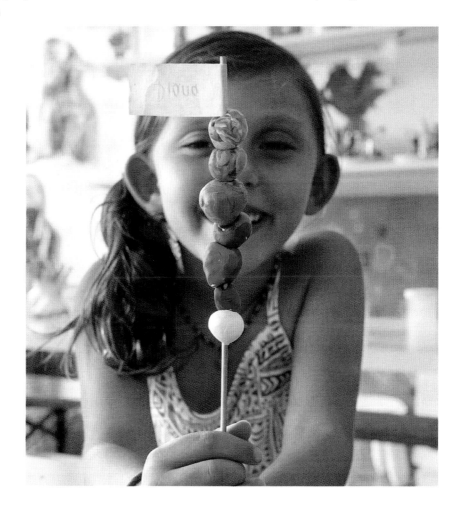

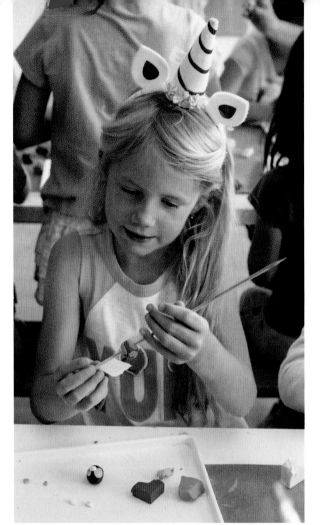

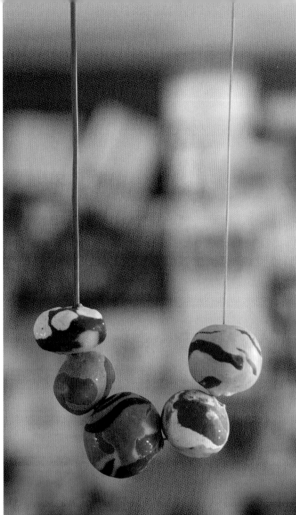

PROCESS Start by rolling a ball of clay about the size of a quarter. You can roll palm-to-palm in your hands or try rolling your clay on the table.

After rolling the balls, gently glide them onto a skewer to create a hole for your beads. Make as many beads as you'd like.

Follow the manufacturer's instructions for baking the clay. Once baked and cooled, string the beads onto string, cord, or yarn.

Art Technique Tip

Try these simple designs:

For polka-dot beads: Roll tiny bits of clay into balls and stick them onto your big ball. Roll that on the table, and the little balls will form polka dots.

For marbled beads: Take a few small bits of different colors of clay and blend them together. This is called "kneading" your clay. Once you mix them together the way you like them, roll your clay into a ball.

For striped beads: Roll your clay into a ball. Take little bits of clay and roll them back and forth into tiny snake shapes. Place those snakes onto your ball and then gently roll it around on your table to form stripes.

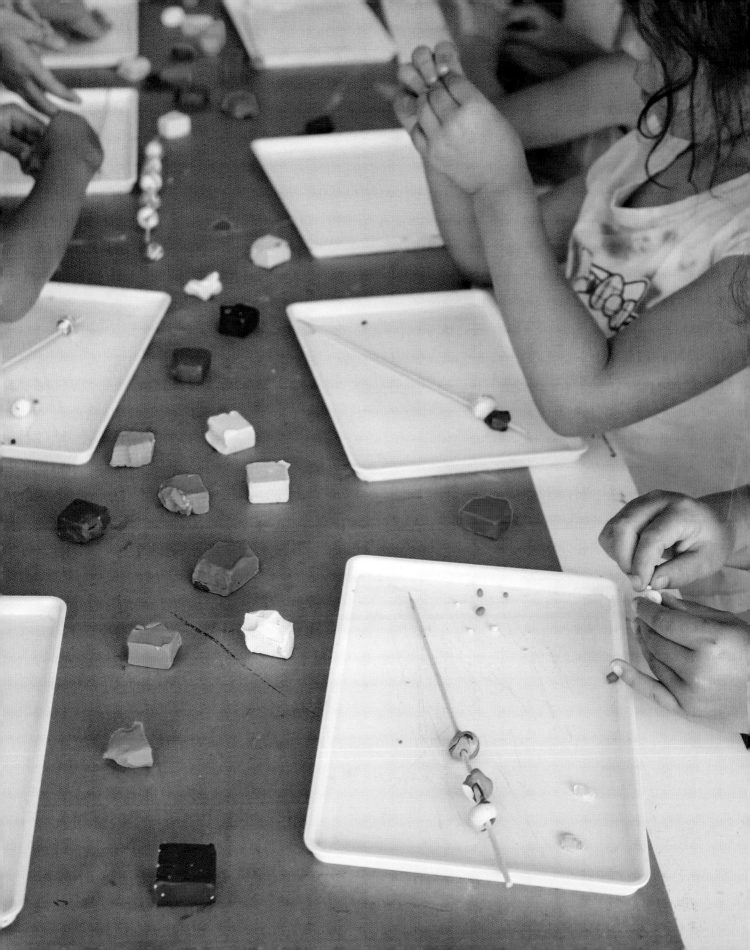

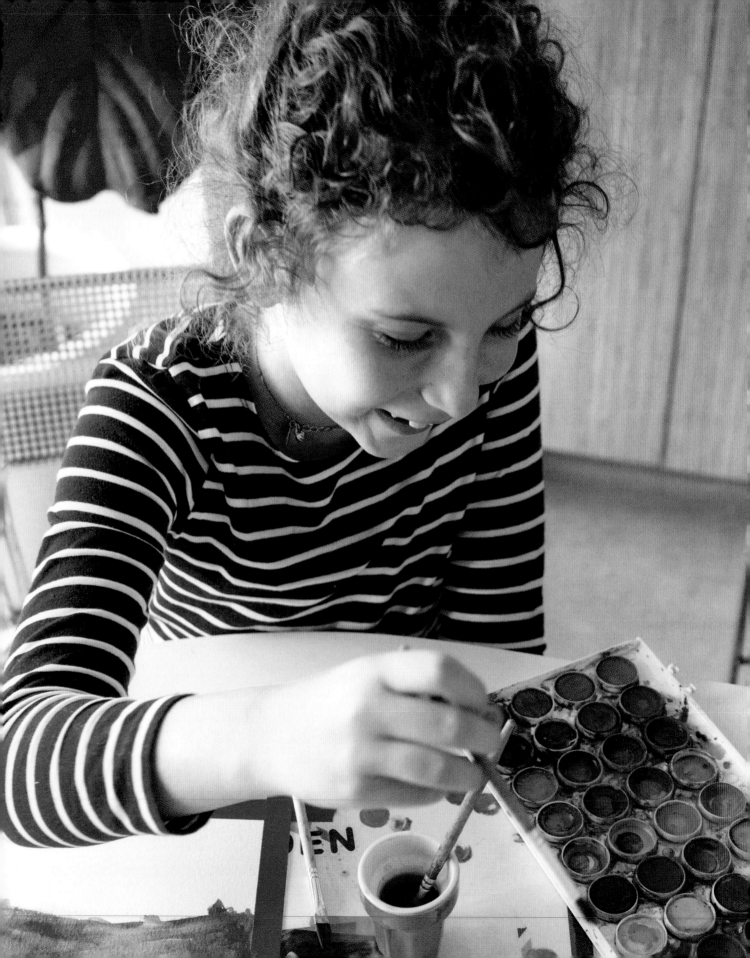

Framed Paintings

Materials

washi tape

sturdy white paper

watercolor palette or liquid watercolors

paintbrush

oil pastels (optional)

salt (optional)

We all want "masterpieces" to frame and hang around the house. Try using this simple technique to turn your child's latest painting into something really special.

Using tape to frame the outer edges of an artwork before creating it leaves pretty much every painting looking like a masterpiece. There are a million ways to make a framed painting. The only rule is to cover the white space along the edge, allowing the tape to make a perfect frame once removed. We used basic watercolors for our paintings. You can also add oil pastels with the watercolors or use them for drawing.

PROCESS

Create the tape frame for your child during your set up. When they sit down to create, invite them to fill the white space inside the tape frame.

Allow the artwork to completely dry before gently pulling the tape off the page to reveal a perfectly framed masterpiece.

Art Technique Tip
Try combining liquid watercolors and salt. After painting, sprinkle a little salt on the damp paint and let dry before brushing away the salt. The salt will absorb the color, leaving an interesting effect.

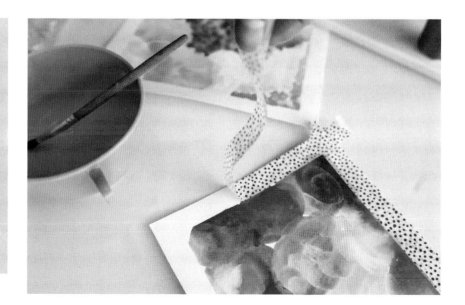

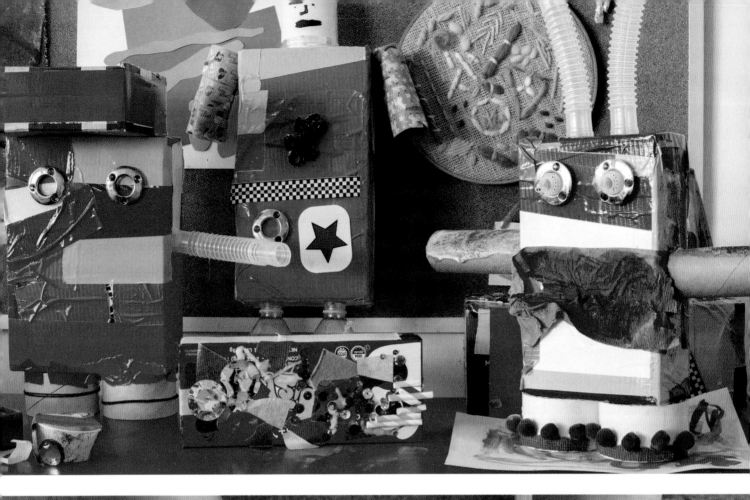

Tinker Station

Materials

small wood bits or plastic shapes

recyclables

masking tape, duct tape, or transparent tape

glue gun

colored paper, felt, stickers, etc.

anything random you find around the house you don't know what to do with

If you have a child who loves to make their own creations, this invitation may be a home run time and time again, and you can always change up the materials. This is a great way to use items that would otherwise end up in the trash or recycling bin.

PROCESS Set out a few interesting objects and recyclables, along with some tape or glue, and look out. Let your little inventor get to work.

Children can use decorative tapes, colored paper, felt, stickers, and anything else you set out to decorate their unique designs.

Pro Art Tip

Does your little one need some inspiration to get started? Here are a few ideas:

House
Robot
Mailbox
Nameplate

Pro Art Tip

A glue gun can be very helpful when working with recyclables. Children should learn to use a glue gun while under adult supervision. Use your own discretion to determine if your child is ready to use this tool.

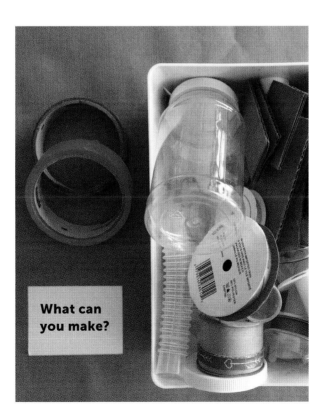

What can you make?

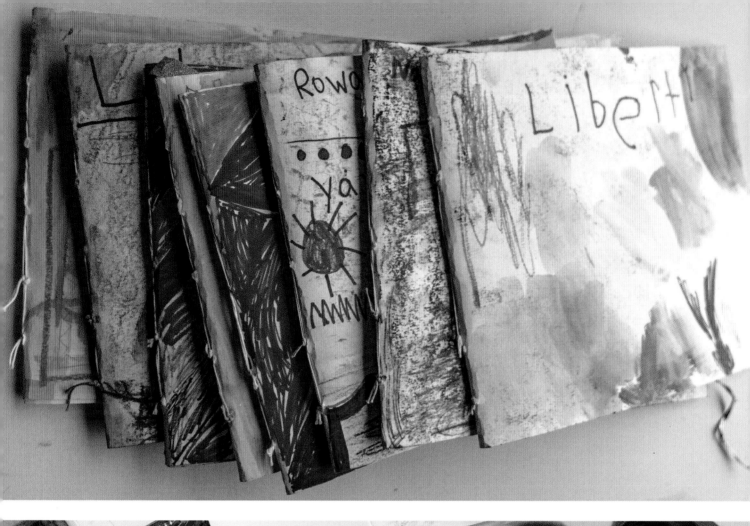

Art Books

Materials

sturdy white paper (We used watercolor paper.)

awl or thumbtack

string

drawing materials

painting materials

stickers and tape

kid's scissors

Pro Art Tip

Different pages can be different daily invitations in your art book. As long as your child is interested, you can put them away or bring them out each day. Art books make great gifts too!

Kids love to make books. You can fill an art book with stories, poems, drawings and paintings, tape collages, stamps, stickers (see page 79 to learn how to make your own stickers) . . . you name it. The best part about art books is that there is no right or wrong way to make them!

PROCESS Start by making the book. You can prepare the book yourself or ask your child to help you make one. We fold three pieces of watercolor paper (cut to any size) and poke four holes along the seam with a sharp tool called an awl. You can use a thumbtack as well, and just stretch out the holes a little bit.

Glide a piece of string in and out of the holes like you're sewing the book together. Tie a knot at each end. You can also simply get out the stapler or just tie a string around the pages by the seam and knot. They'll stay in place pretty well. Cut off any extra string using the kid's scissors.

Children can fill the pages of the book with their own original artwork, using drawing and painting materials, stickers, and tape.

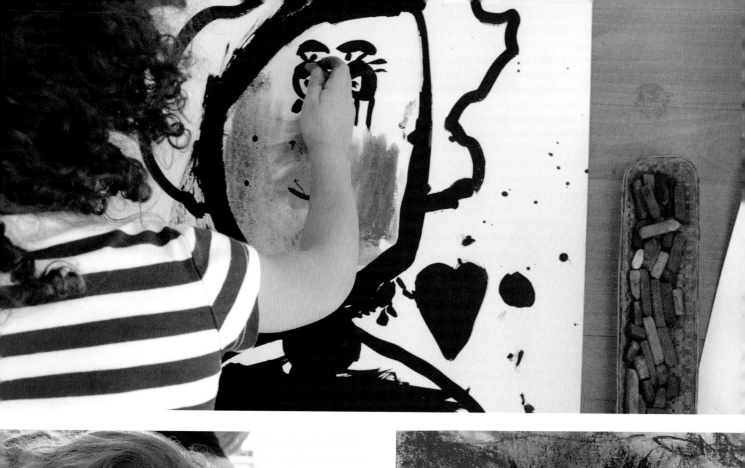

Big Self-Portraits

Materials

mirror

large piece of watercolor paper

black sumi ink and brush (optional) or black permanent marker

chalk pastels or liquid watercolors

These oversize self-portraits are one of my all-time favorite projects to do with kids of all ages. They come out so alive and full of personality. There are a few ways to do these, based on your comfort level. The messy version is with black sumi ink, a wet saturated ink that glides over the paper. The results are awesome. If that sounds too intense, try a permanent marker or other thick black marker or black paint. You'll still get great results.

PROCESS

Follow the same process as the mirror self-portrait invitation on page 49, but this time use big paper and encourage your child to go as big as they can on the paper. Use their first self-portrait to show the difference between big and small.

Your child can use sumi ink to paint or a thick black marker to draw. Once they draw or paint their big self-portrait, let it dry, and then fill in the white space with chalk pastels or liquid watercolors. Then frame!

> **Facilitator Tip**
> *I remember begging my younger daughter to do a self-portrait one time. She didn't want to and I kept pressing. I wanted something great to hang in her room. She finally did it, refused to draw a neck or color certain areas, and I was basically trying to control the whole thing. Her portrait looked as tortured as I was acting. We all want the masterpieces. I get it. Sometimes we've got to just give it up and let our kids be. Trust me, I'm learning right along with you.*

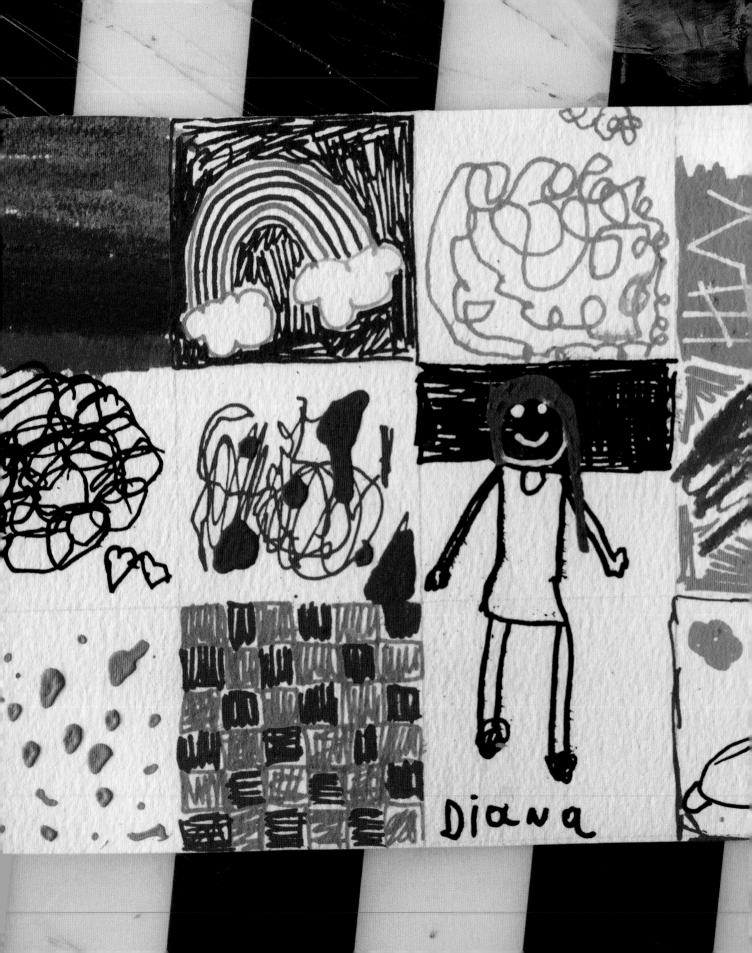

Diana

Inside the Box

Materials

pen or pencil

straightedge
(such as a ruler)

sturdy white paper

markers

watercolor palette
(optional)

Pro Art Tip
*This would
be fun to do
with the whole
family. Each
person can take
a turn filling in
a square. You
could also try
circles instead
of squares.*

Usually I like to think outside the box, but there is an exception to every rule. This invitation is all about staying in the box. Draw a grid as big or small as you'd like, and have fun creating inside each box in different ways. My five-year-old and I did this as a collaborative project, taking turns drawing in the boxes. You can use any materials you want. I love our little grid. It's so happy.

PROCESS Start by using a pen or pencil and a straightedge to draw a grid on a piece of sturdy white paper. You can make the squares as big or as small as you like.

Your child can create something new in each box, using markers, watercolor paints, or other materials.

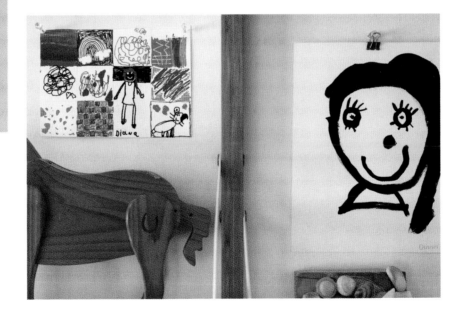

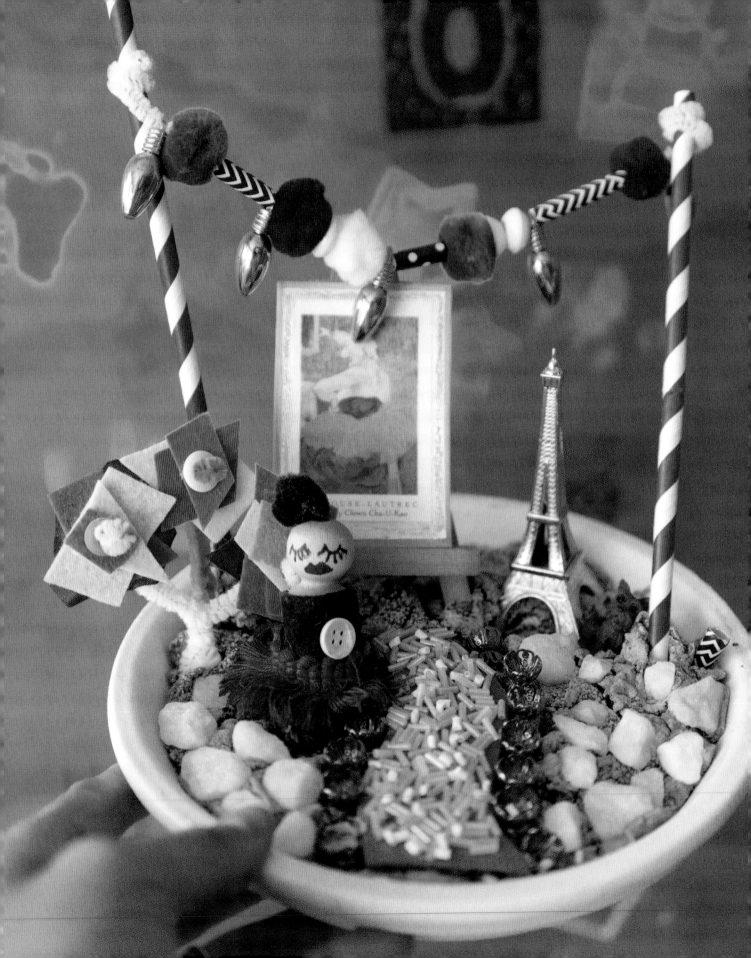

Small Worlds

Materials

playdough

small plate

beads of all kinds

pipe cleaners

empty toilet paper rolls for buildings

cut-up felt and paper

corks or wood pegs for people

craft sticks and little cards for sign making

sticks and pinecones

Pro Art Tip
Take it outdoors and use nature bits to try making mini versions in a large recycled plastic lid.

What's in your world?

Small worlds are a staple project and process at Meri Cherry Art Studio. We use playdough as a base inside a plate (often a terra-cotta plate), allowing children to freely press in whatever objects they wish to create in their world. There is no right or wrong way to do this. If your child likes Paris, it can be a Parisian world. If they like Halloween, it can be a haunted world. If you have a fairy lover, then fairy worlds it is. It's really up to you and what you have around the house. Shown here are some examples of materials and small worlds we've created.

PROCESS Press playdough into a small plate to create a base for the world. Your child can create whatever kind of world they like by pressing items into the playdough to create houses, scenery, gardens, etc.

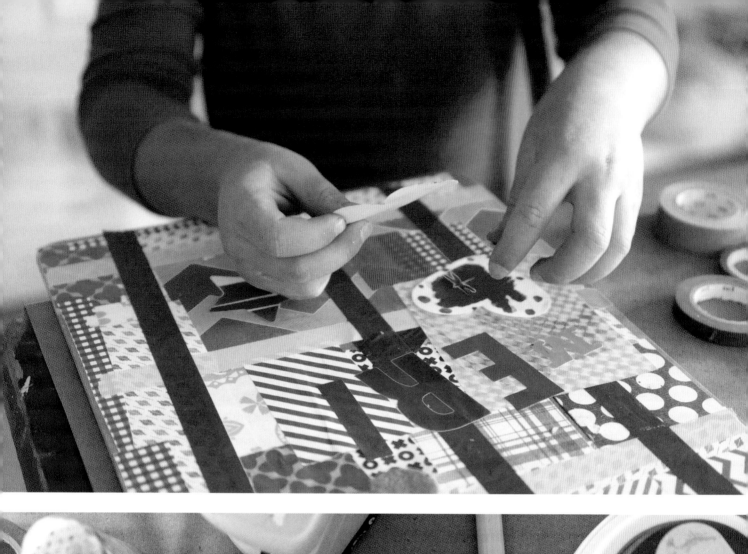
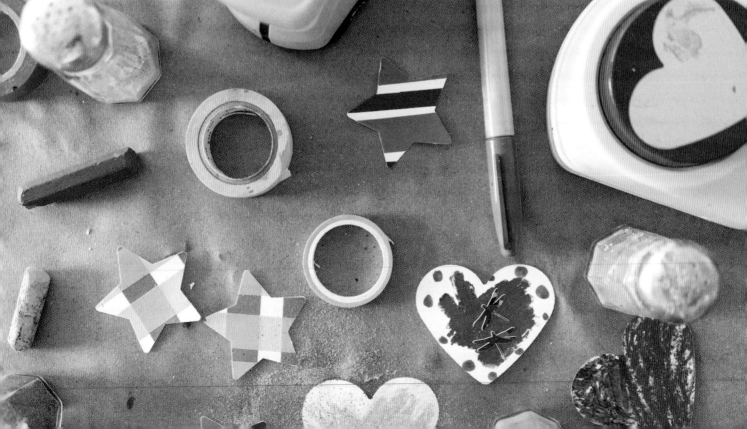

INVITATION TO CREATE

Sticker Making

Materials

kid's scissors

white sticker paper or large, blank shipping labels

permanent markers and gel pens

washi tape

glitter (optional)

Sticker making is another staple in our studio because it's great for all ages and super fun. Plus, the possibilities are endless, and you can make a little sticker bag to hold your collection. You can use shape punches from your local craft store for different shapes, or just cut out some shapes freehand. Hearts, circles, and stars are always a good place to start. Then just get decorating. All the listed materials are just suggestions. This is another invitation with so many variations. Start simple and get more advanced as you go.

PROCESS

Cut out different shapes from white sticker paper or large, blank shipping labels to make an assortment of blank stickers.

Children can decorate the blank stickers with permanent markers, gel pens, washi tape, or even glitter. You can also decorate the entire page of sticker paper and then cut out the shapes.

Pro Art Tip
Stickers are great for adding to art books (see page 71), trading, collecting, and sending to friends and family.

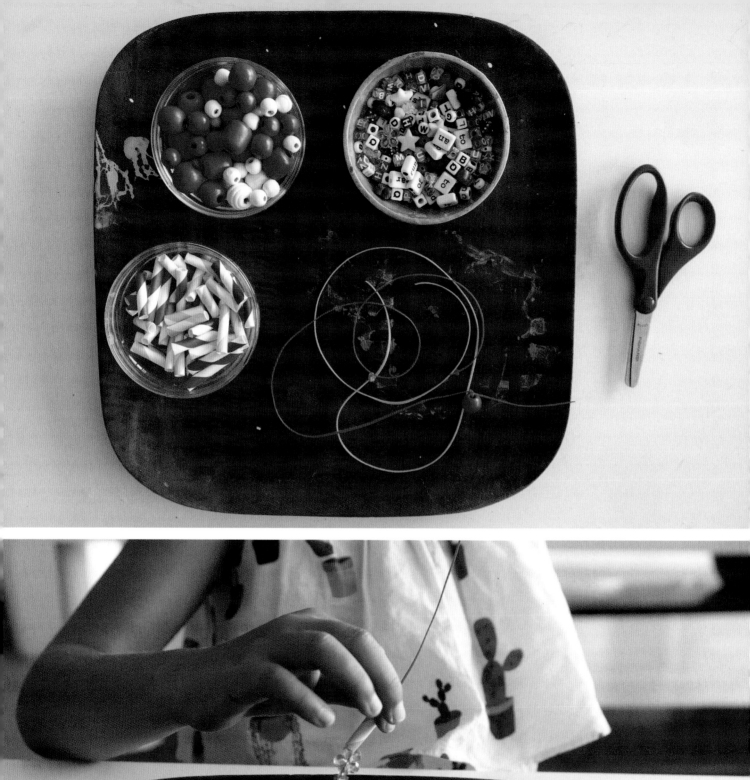

Beading

Materials

kid's scissors

string, lanyard, cord, or wire

assorted beads

Don't underestimate the simplest activities when setting up an Invitation to Create.

Just some basic beads and cord can be engaging for your child and give them great practice using their hands, while making something they love. You can get more and more advanced with your beads or substitute wire for string over time. We like to tie a bead to the end of our string as a "stopper." This helps kids navigate how to start and prevents tears from sudden spills.

PROCESS

Cut a piece of string, lanyard, or cord to the desired length. Tie a bead at the end to act as a stopper.

Your child can add as many beads onto the string as they like. They might add them randomly, or perhaps you might encourage them to try creating a pattern of colors or bead types.

"Oh wow, I see you're using the pasta like a bead. What a great idea."

Collage

Materials

white glue and brush

glue sticks

magazines and scissors or precut magazine pictures of interest

cut-out drawings

printed pictures

canvas, large paper, or piece of cardboard

paint (optional)

Pro Art Tip
Teach your child the "Artist Trick." The trick is dipping your brush in glue or paint and wiping it several times on the side of its container to prevent dripping.

When you hang your child's art you are saying, "Your work is important to me. It has value. I am proud of the work you do."

I've always loved collage, which is simply gluing together different materials to make one work of art. It's a great process-based experience that can be so much fun for kids of all ages—and adults too.

Young children will just enjoy the gluing, while older kids might enjoy cutting out their artwork and putting it next to magazine pictures or printed pictures. I recommend using glue in a recycled container with a brush. You might want to introduce collaging items one at a time to keep interest going, or you can put it all out on the table and see what happens.

We've done individual collages, collaborative family collages, and tons of mixed-media works for place mats, clipboards, and framed works around the house.

Basically, the process is to glue cut-out pictures, papers, and objects of interest onto a small or large surface. There are no rules, and you can keep coming back to collage over time.

Your child can further embellish their artwork after all the glue dries by adding paint on top of the collage.

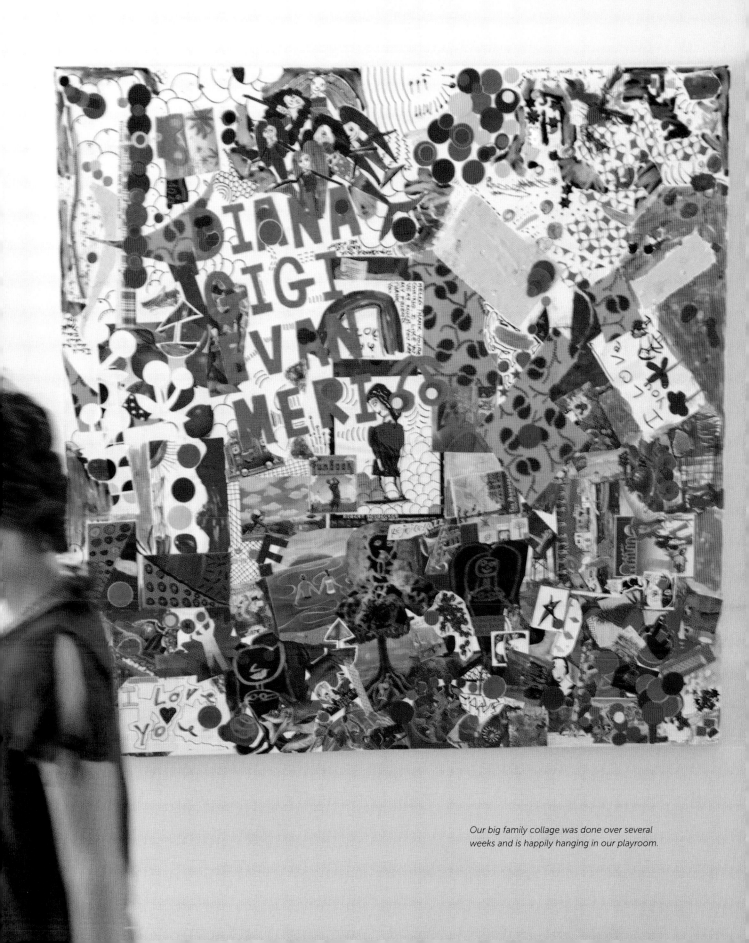

Our big family collage was done over several weeks and is happily hanging in our playroom.

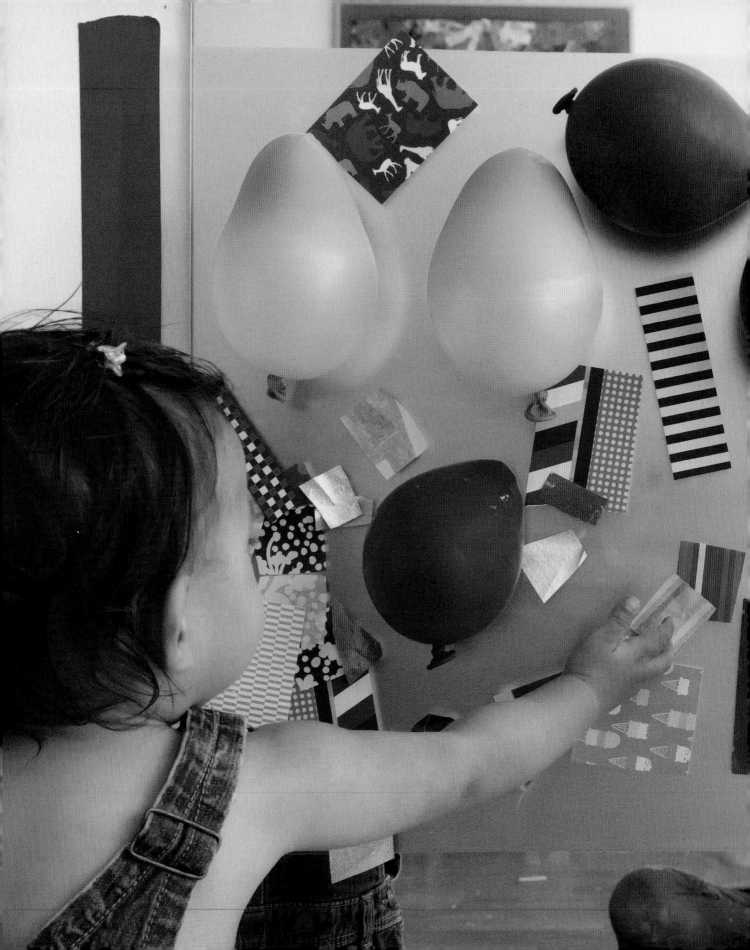

Chapter 4

INVITATIONS TO PLAY
SENSORY-BASED ACTIVITIES

Invitations to Play do just that: invite play. They are great if you have children in multiple age groups. The materials will meet the children wherever they are developmentally. If you have a child who leans toward perfectionism, Invitations to Play are also a great place to start. Besides following your play and safety rules, there is no way to do any of these wrong. You might be surprised to see the older kids dive into the invitations that follow just as much as the younger kids. I'm always amazed to see a group of six-year-olds engaged in baby washing like it was the most important task they've been given all week. Kids need opportunities to decompress and let loose from all the pressures they experience in their daily routine. Invitations to Play are a great outlet for fun and play. In this chapter, I've included some of our favorite recipes that we use over and over, which can be incorporated into other ideas throughout this book.

Homemade Playdough

Materials

1 cup (128 g) flour

⅓ cup (100 g) salt

1 tablespoon (15 ml) oil

2 teaspoons cream of tartar

1 cup (237 ml) water and food coloring

bowl

spoon

pan

stove

Please do not underestimate the value of homemade playdough. It is a game changer. Once you make it for the first time, you'll never go back to store-bought. Everyone has their favorite recipe. This is ours. You can keep this playdough in a sealed plastic bag for months and it won't go bad. It's smooshy and soft and smooth and can lead to countless activities. See our Small Worlds invitation on page 77 for one of our favorites.

PROCESS

Combine the flour, salt, oil, cream of tartar, water, and food coloring in a bowl and stir. Transfer the mixture to a pan, place over low to medium heat, and stir until the playdough starts to clump around the spoon. Keep mixing and then, poof! It will be playdough. Remove and let cool, then PLAY. You might be like, "Um, I don't think this is working," for a minute, but don't worry. It will start to firm up all of a sudden, and you'll know you're a rock star. Promise.

Pro Art Tip
Make playdough in the primary colors (red, yellow, blue) and practice color mixing.

Invitation Ideas with Playdough

Provide your children with playdough, craft sticks, and dry tube pasta to make inventive sculptures. Use playdough to make cupcakes. Kids can fill cupcake tins with paper liners and dough and decorate with buttons, straws, and glitter. Serve up playdough with nothing more than a pair of scissors and kids will enjoy cutting up all kinds of shapes.

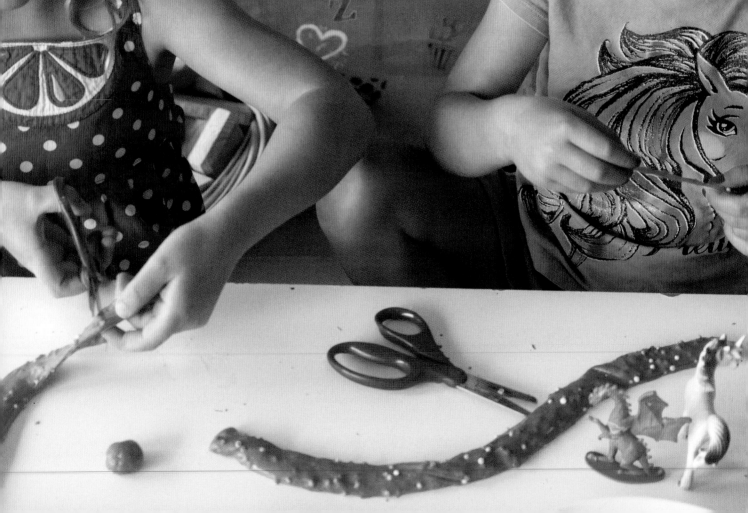

Homemade Slime

Materials

white glue

clear Tide liquid laundry detergent

bowl and mixing spoon

food coloring or colored air-dry clay (optional)

Pro Art Tip
To help achieve the perfect consistency, try keeping your slime in an uncovered bowl in the refrigerator overnight.

Slime . . . you either love it or hate it. Usually, if you're a mom, it's the latter, but I'm here to tell you I have a new fondness for slime and have recently removed the ban on slime from my house.

We use a super-easy recipe and have implemented strict rules on where slime making can occur so I don't lose my mind. The truth is my kids love it so much, and they will play and play and play with it, so we had to reach a compromise. Our rules: It MUST be played with in an area with no carpet or rugs anywhere near the slime and on a clean table with nothing else on it, all chairs removed from the scene, and all hair must be tied back. These are the rules, take 'em or leave 'em, kids. Otherwise, mama has a meltdown. Trust me, you're not alone.

Our favorite super-easy recipe: clear Tide and white glue. That's it.

PROCESS Combine three parts white glue with one part clear Tide liquid laundry detergent in a bowl with a spoon. If you want some color, add a few drops of food coloring. Keep mixing it until the mixture becomes slimy, and then use your hands, moving it back and forth in your palms until it feels like slime. The key is to keep it moving in your palms. The more you do that, the more it will become activated. If you didn't add food coloring but still want some color, add air-dry clay to the slime and keep moving it with your hands. If you find your slime isn't activating, add a bit more Tide and continue to mix. Keep adding small amounts until you have the desired consistency.

There are lots of things you can do with slime. Kids can cut it, twist it, make large bubbles, squeeze it, separate it . . . you name it. Kids will intuitively know what to do, trust me.

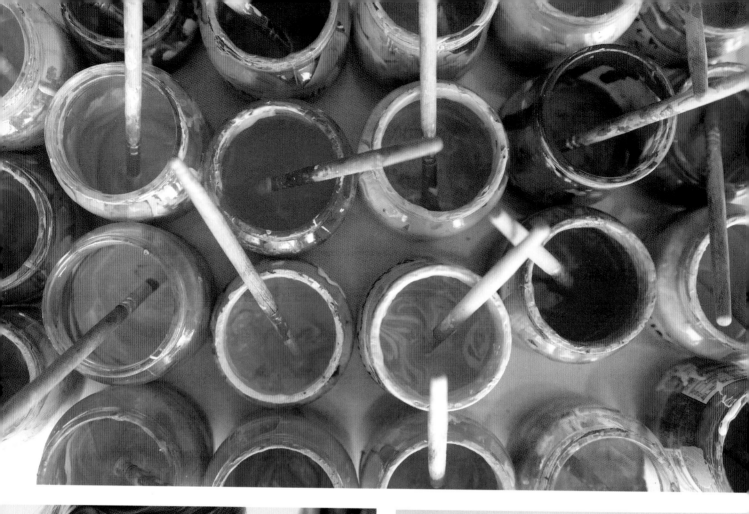

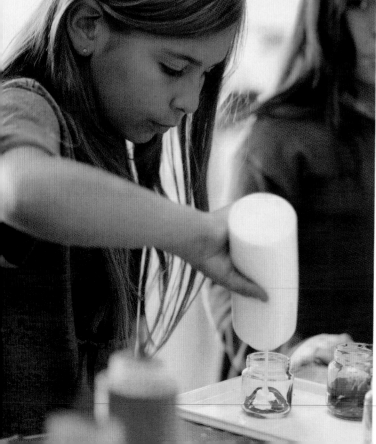

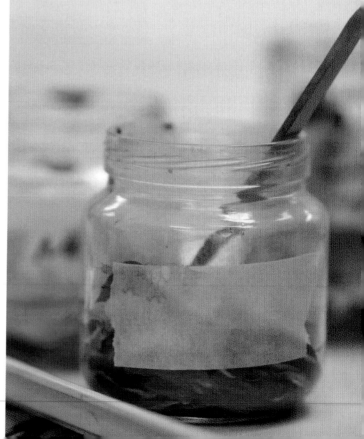

Paint Mixing

Materials

red, blue, yellow, white, and hot pink (optional) tempera paint (any brand will do)

baby jars or other containers

craft sticks

masking tape

permanent marker

Pro Art Tip
Encourage kids to add a little white to their colors to make them extra beautiful.

Paint mixing is a process-art staple. With the exception of hot pink, we don't even buy more than the primary colors and white around here. All the colors you see in this book are made right here in the studio. If you have a pink and purple lover, hot pink—rather than red—makes really good shades of purple and pink.

PROCESS

Invite kids to pick any two primary colors they want, plus white, to squeeze into a jar. This part takes some monitoring by the adult. Kids love to squeeze and often don't have the chance to work like this. Make sure you keep a watchful eye on the paint squeezing. I demonstrate squeezing for a count of three to avoid over-squeezing. This may take some practice.

After squeezing in the two primary colors and some white, get a craft stick and start stirring. As kids stir, have them think about a name that might match their color. Get creative. Naming paints can be super fun. If your child only wants to mix one primary color with white, that's just fine. Adding white to our colors is an aesthetic thing. We like colors to be light and bright. This also gives an opportunity to talk about dark and light. You may have a different aesthetic. It's all good.

You can save your paints for different activities throughout this book. Label the containers with masking tape and a marker. Be gentle with your lids if you're using baby jars to store paint. You can just sort of place them on top. Sometimes the paint will harden around the lid if you twist them on, making them really hard to open.

Pro Art Tip
I like to put the paint in squeeze bottles, as you can see in the pics, although you can squeeze right out of the original bottle. I find squeeze bottles are really easy for little hands to squeeze, and you can cut a snip off the top with scissors if the paint gets clogged. They also look pretty, and there's nothing wrong with that.

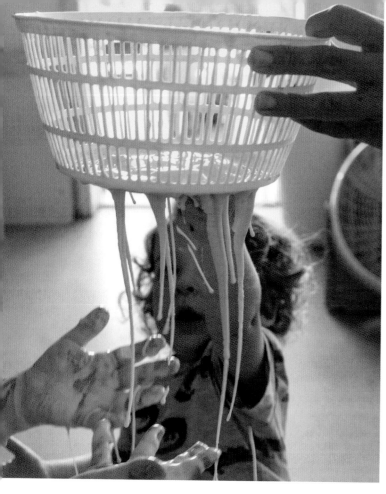

I totally get it. Some sensory activities are just too much for some kids (and their adults) and they need time to get into it. This is one of the core reasons we repeat sensory activities so often at our studio. If you just try something once and your child doesn't go for it, they don't have time to develop risk-taking and gradually build confidence. Give your child the gift of time and patience. Try something one week and then again the next. Maybe the second week they touch something with a fingertip after not touching at all the week prior. That's a win. There is nothing wrong with giving them a wash bowl to ease their anxiety. Before you know it, they may be in the tub half-naked, happy as can be. Just be prepared to hose them off before they come inside.

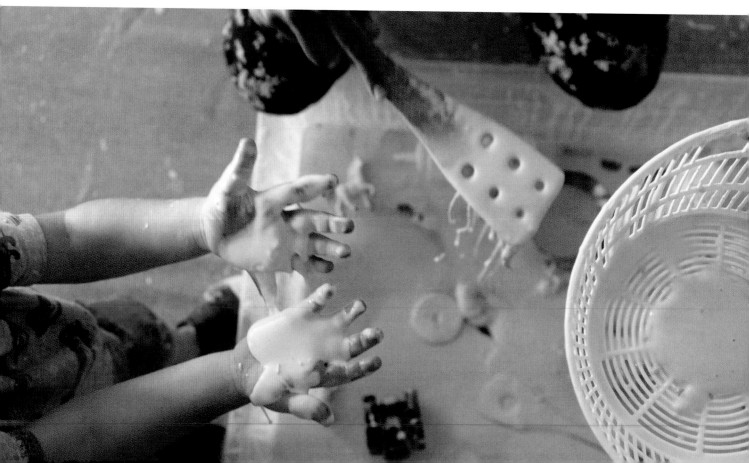

Oobleck

Materials

cornstarch and water

large tub or bin

wooden spoon

food coloring (optional)

small bowls

little figures (optional)

pasta strainer (optional)

Pro Art Tip
Oobleck at its most fascinating consistency is a little thick when you move a spoon or your hand through it. You kind of have to experience it to see what your child prefers and what Oobleck is all about.

Oobleck is a slime substitute that we've been using for years. It's super easy and you may have all the ingredients in your cabinet already, which is always a bonus. It's just cornstarch and water. This is another science-based play activity. Wet cornstarch turns from a liquid to a solid with movement. It's super cool. Parents are always as equally fascinated as the kids.

The cool thing about Oobleck is that it rinses off with water easily, so the mess looks way worse than it is. Having said that, I still apply my slime rules or do this activity outside. Kids can play individually or with a group in a large bin. You can add a lot of things into Oobleck to make it more interesting. I recommend starting with straight-up Oobleck in a bowl to introduce it. The next time, or as kids are playing, add in their favorite plastic figures, like dinosaurs or unicorns or cars.

PROCESS

Combine about 1½ cups (192 g) cornstarch with 1 cup (237 ml) water in a tub or bin, stirring well with a wooden spoon. Add more water or cornstarch as needed to get the consistency you like. You can also add food coloring. You may find it easier to add the food coloring to the water before mixing it with the cornstarch.

When the Oobleck is the right consistency, scoop it into individual bowls for kids to play with, or they can play together in the bin. Kids can play with their favorite plastic figures or with just their hands. A pasta strainer is also really cool because you can fill it with Oobleck and it creates a great shower oozing out the bottom as you hold it up.

You may want to keep a bowl of water next to your tub for kids who want to be able to wash their hands in between handling sessions.

Invitations to Play are great for multi-age groups of kids and outside playdates—this one especially!

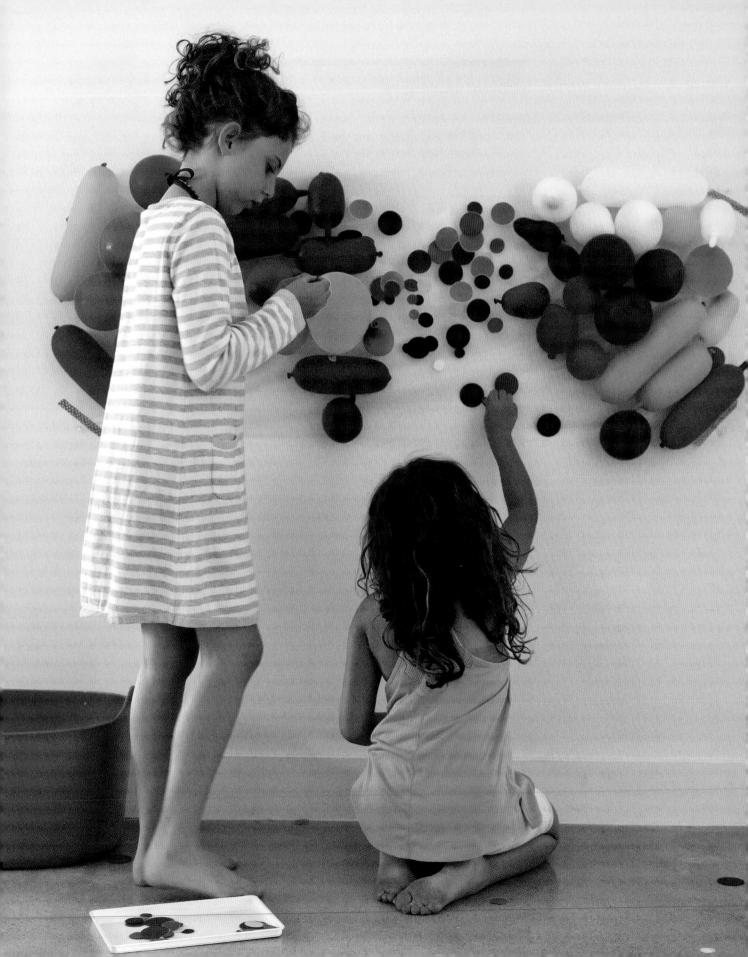

Sticky Party Mural

Materials

roll of contact paper

painter's tape
or masking tape

pushpins (optional)

few balloons

any kind of colorful embellishments you can find around the house (feathers, ribbons, cut paper, cotton balls, fabric bits, etc.)

Pro Art Tip

Have a birthday party coming up? Try a Sticky Party Mural and place cutout "Happy Birthday" letters to start it off.

Contact paper taped to the wall, sticky-side up, is a great base for a super fun party mural of mega-happiness proportions. The only challenging part is hanging the contact paper . . . this is a two-person job.

PROCESS Cut a sheet of contact paper to your desired length and start to peel off the back of the paper, letting your buddy pull the length of the paper as you peel. Use painter's or masking tape or pushpins to attach the contact paper to the wall, sticky-side out. You're ready to get stickin'.

Kids can decorate the contact paper with balloons, feathers, ribbon, cotton balls, and any other colorful embellishments you have available for this activity.

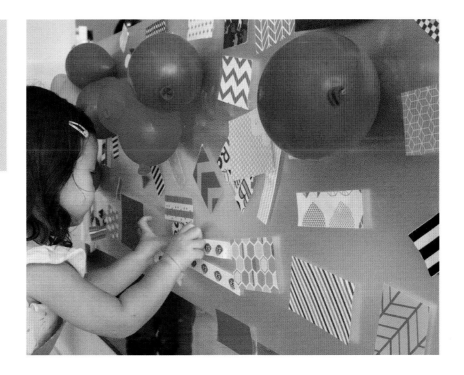

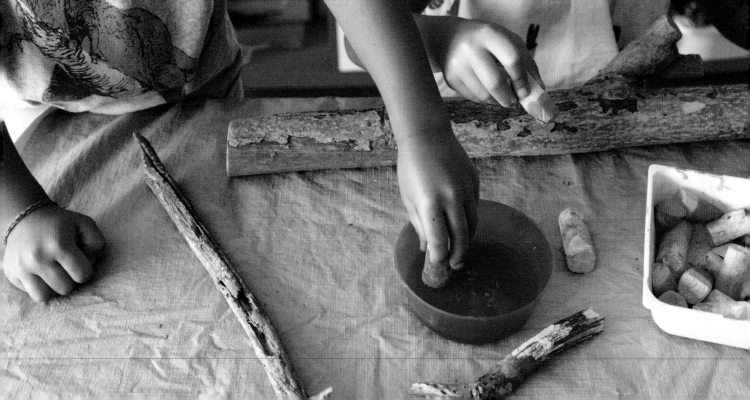

Wet Chalk Painting

Materials

water in bowls

jumbo chalk

paper, cardboard, branches

driveway

This is another super simple invitation that always surprises me. Give a four-year-old some wet chalk and look out!

It seems like we all have those big thick pieces of chalk hanging around somewhere. Put them to fun use by adding water and you've got a whole new chalk-drawing experience. Chalk dipped into water turns into a paintlike consistency and is super fun and satisfying to work with. You can try it on paper, cardboard, large branches, the sidewalk, etc. Get creative.

Pro Art Tip
Restore the damp pieces of chalk to normal by allowing them to dry in the sun when you're done creating.

PROCESS

Set out bowls of water and pieces of jumbo chalk with paper, pieces of cardboard, or branches to draw on. You can work indoors on a protected work area or take it outside so kids can draw on the driveway too. Dip the chalk in the water to dampen and draw away!

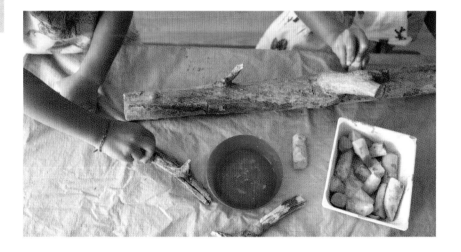

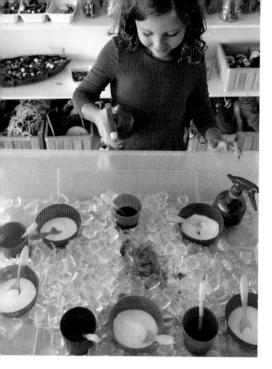

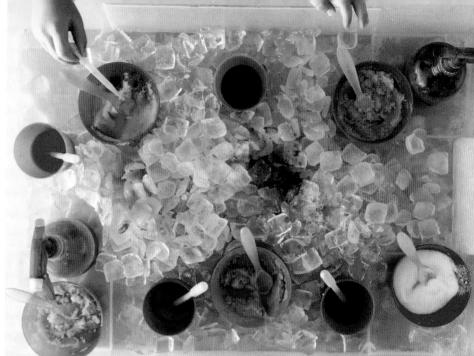

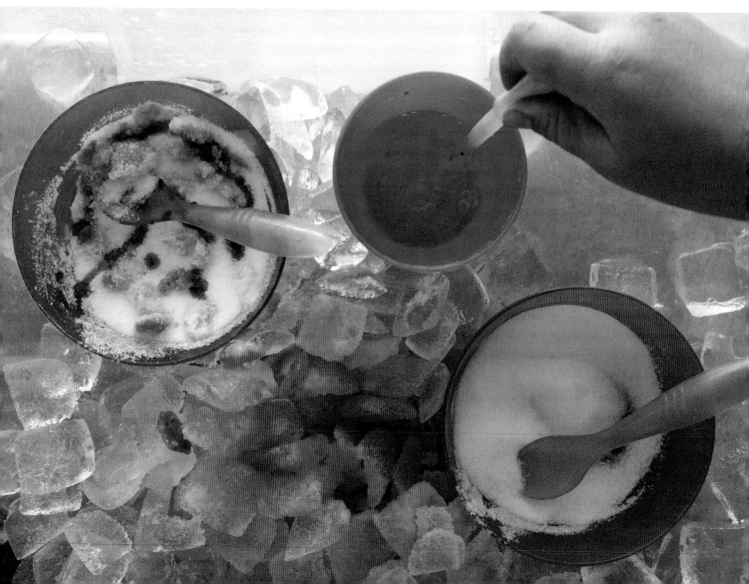

Ice Sculptures

Materials

small bowls of salt

ice cubes or blocks

liquid watercolor or food coloring and water in plastic cups

little spoons

pipettes

spray bottles of colored water (optional)

dinosaur figures (it can be the ice age) (optional)

glitter (optional)

Pro Art Tip

Be sure to use plastic containers for the watercolor. Glass can break up against the ice.

I love ice sculptures. They are always so gorgeous and magical looking. You can do them individually or as a group. Just set some ice out in a bowl or large bin. Add bowls of salt, liquid watercolor or food coloring, water, spoons, and pipettes and you've got a great science-based invitation that is fascinating for kids of all ages. The salt will begin to melt the ice and create a textured, absorbant surface, and the addition of liquid watercolors creates bright melting streams of color. You can add glitter for extra sparkle, or your favorite small toys, such as dinosaurs or unicorns to make your world more magical.

 PROCESS Kids can sprinkle salt over the ice and watch as it absorbs color as they drop small spoonfuls, squirts, or sprays of colored water over it. We encourage the kids to "make it snow" over the ice and see what happens.

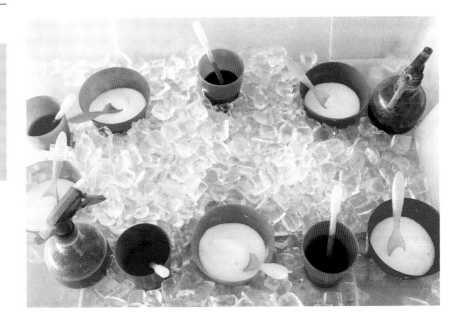

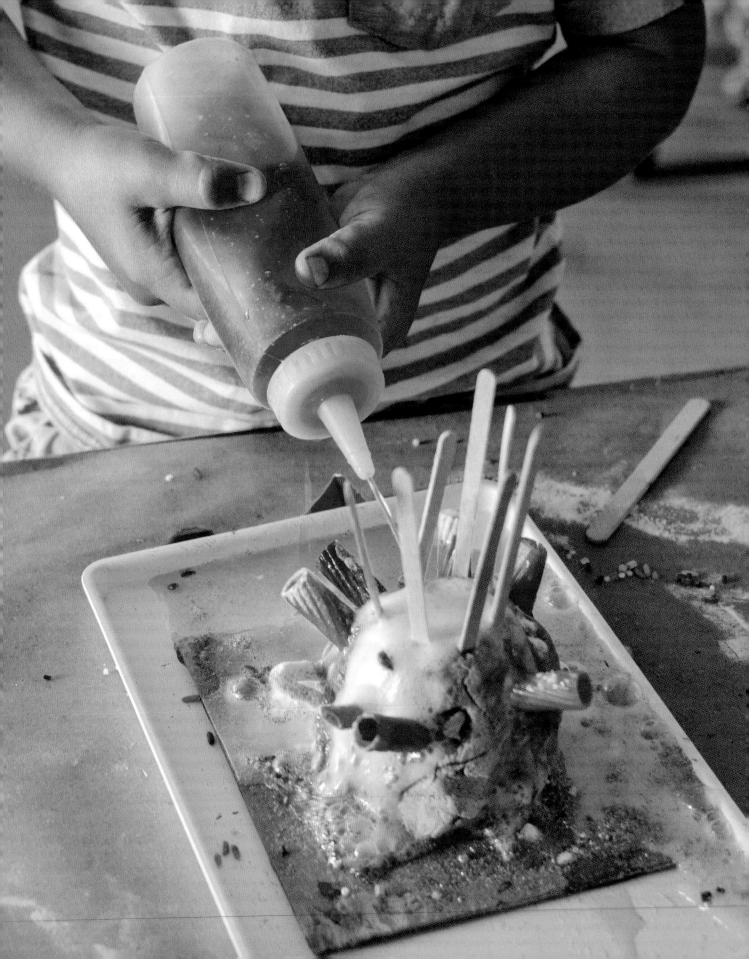

Volcano Eruptions

Materials

old playdough mushed together

piece of cardboard (about 5 x 5 inches [12.7 x 12.7 cm])

random items, like pasta, craft sticks, beads, or anything that's fun to stick in playdough

white glue and paintbrush

baking soda in a bowl with a spoon

glitter (optional, always optional)

vinegar in a squeeze bottle

food coloring (optional)

Pro Art Tip
Mess alert! This is a super fun invitation, but it's messy and may be best for outside or a spot with no carpet.

I have yet to meet a child who does not want to make a volcano erupt. Here's a super simple way to make it happen. I have to thank our studio team member Rachel for this one. It's a winner. Plus, you get to use up all your old, brown mushed-up playdough that no one wants. Bonus.

This is a two-part invitation. You can make the volcanoes one day and have them erupt the next day.

PROCESS

1 | Make the volcanoes using old playdough stuck to a piece of cardboard and add random embellishments. Make sure there is a hole in the volcano for the eruption materials. You can make the volcano around a plastic cup for a bigger hole. The bigger the hole is, the more room for eruptions. Paint the volcano with white glue so it all stays together. Let dry overnight. You probably could skip this part, but it extends the activity and builds excitement.

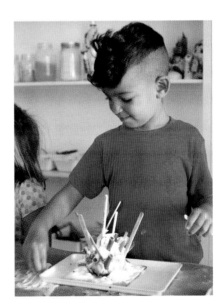

2 | Set out the baking soda and vinegar. We added some food coloring to our vinegar for fun. You can even add some glitter at this point. But remember: Glitter is always optional, so if it stresses you out, feel free to skip it. Invite your child to fill the hole with baking soda and then see what happens when you squeeze in vinegar. The kids will take it from there. Have fun!

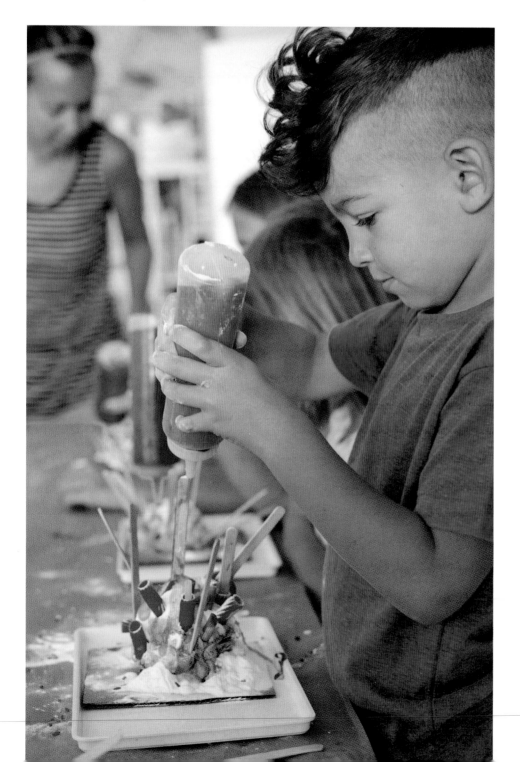

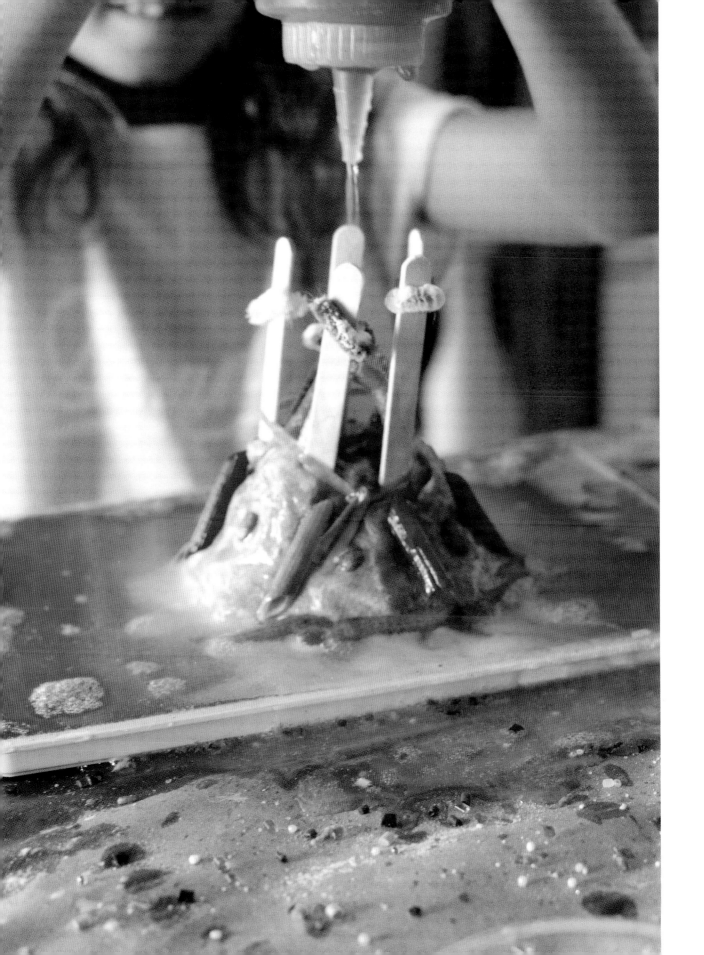

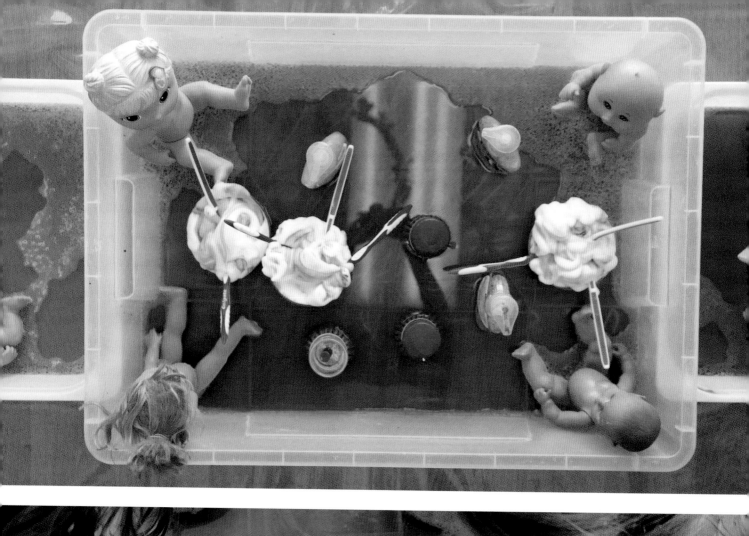
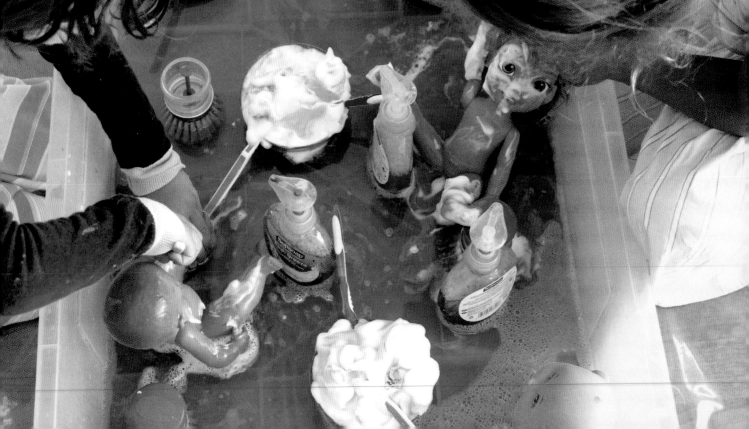

Baby Washing

Materials

large plastic bin or tub

food coloring (optional)

shaving cream (for shampoo)

soap in a pump bottle

toothpaste and toothbrushes

plastic babies

sponges or washcloths

towel for drying

tempera paint in cups (optional)

Pro Art Tip

Add in a few bowls of tempera paint, and kids can paint the babies first and then give them a bath.

Kids of all ages love to wash babies. You might be surprised to see the five- and six-year-olds have even more fun than the toddlers washing the babies, brushing their teeth, and shampooing their hair. This is one of our all-time favorite activities. It's almost as fun as washing a real baby, and good practice in caretaking and building empathy.

PROCESS

Fill the bottom of a large tub or bin with water. You can add food coloring to the water and shaving cream to make everything more colorful. Kids can use the shaving cream, soap, and toothpaste to give their babies a bath and brush their teeth. Let them use a range of sponges and washcloths. When they're all done, time to dry off!

107

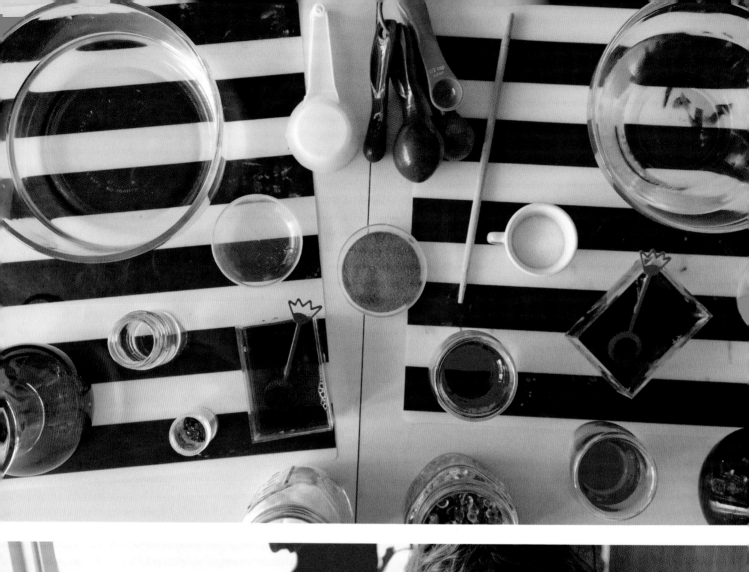

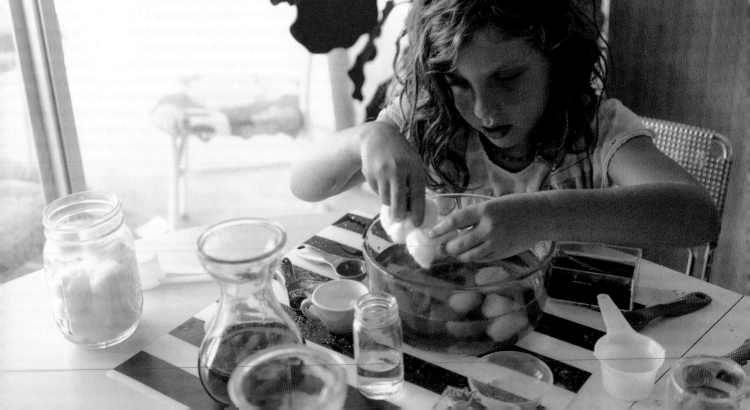

Science Station

Materials

clear bowls of different colored water (Food coloring works great.)

serving and measuring spoons

pipette or two

cotton balls

salt or baking soda

soap or bubble solution

glitter (optional, always optional)

Pro Art Tip

If you set out baking soda as one of your materials, it might be fun to include a small spray bottle of vinegar too, so kids can explore the fizzing chemical reaction!

Of all invitations, I think this one, or variations of it, has been our biggest hit, time and time again.

Science stations are simple to set up and can be done over and over again. Pretty much everything you need is in your kitchen cabinet. Feel free to substitute any of the materials listed with what you happen to have. Set everything out on a tray or place mat and see what your kids come up with. I dare your kids not to enjoy this invitation.

PROCESS

The best thing about science stations is that there aren't any rules or steps. Simply set out all the items and encourage your child to experiment with each of them to see what happens.

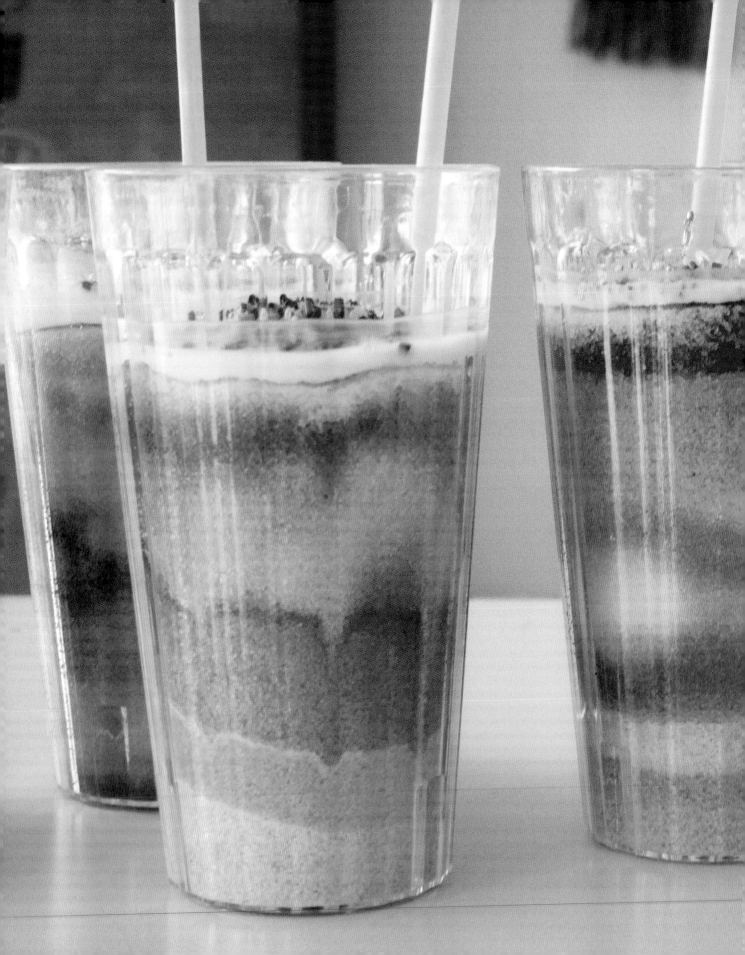

Chapter 5

BIG PROJECTS
ONGOING PROCESS-ART ACTIVITIES

If you made it this far, you might just be a process-art superstar, so take a moment to give yourself a big hug. Go ahead. I'll wait.

If you're still game for more, here are some bigger projects that incorporate and build upon a lot of the ideas from the previous invitations. By now you're such a pro, you can see how you can break these down into separate invitations as well. It's hard for some kids to sit and do a whole project in one go. Helping them break things down, go slow, and work on something over time is a great life lesson.

The projects we've shared thus far include many of our all-time absolute favorite activities. My daughter Gigi's favorite is Trace Your Faves and Didi's is Science Station. You'll find my favorite in this chapter: the Crazy Contraptions. I'm a sucker for anything that involves giving a girl a hammer, but that's just me. Take a look and see which one speaks to you and your child, then get going. You can do this! I believe in you.

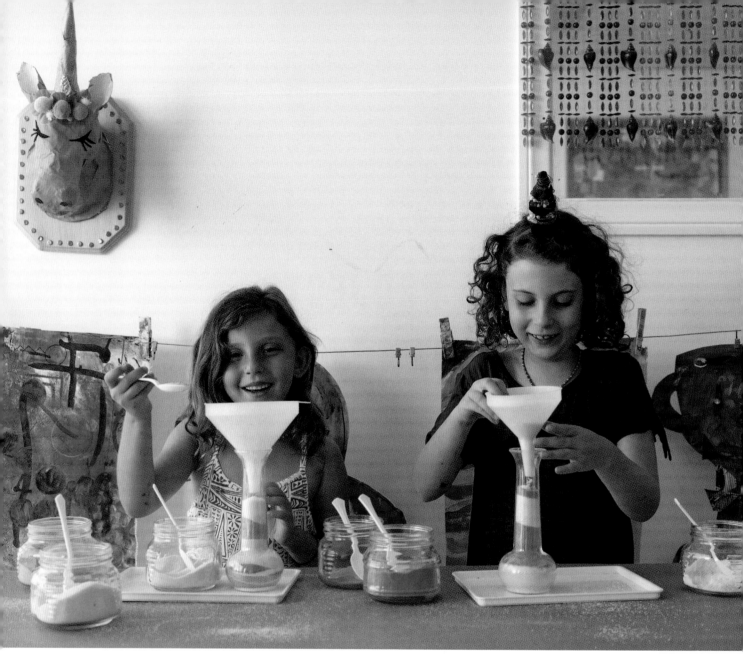

Dyeing Salt

Place the desired amount of salt in a plastic bag and add about a tablespoon of rubbing alcohol and your favorite shade of food coloring or liquid watercolor. Seal the bag and shake until all the salt is the desired color. You can add more food coloring if you want a more vivid color. Unzip and let it air-dry overnight. Repeat with as many colors as you want.

Rainbow Smoothies

Materials

dyed salt in separate bowls

spoons

funnel (optional)

clear container for your smoothie (A recycled cup or water bottle works great.)

decorative straw

white glue

little beads for sprinkles

red pom-pom for a cherry (not pictured, but super cute)

Pro Art Tip
If you don't want to dye your own salt, you can buy colored sand online or at your local craft store—it will work in the same way.

My daughters created this project and it has been a huge hit in the studio and at home. We're always looking for new ways to work with interesting materials, and salt is an inexpensive material that we use all of the time in the studio.

PROCESS

1 | Invite your child to spoon different colors of salt into a clear container to create their smoothie. Fill the container about three-quarters full.

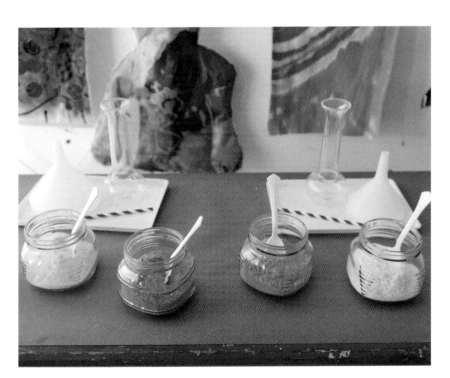

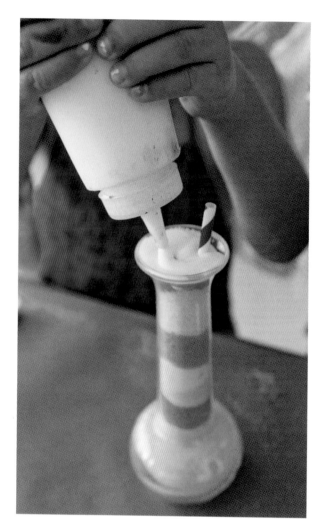

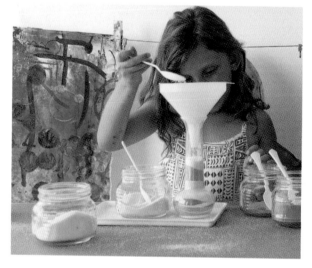

2 | Gently stick in your straw and add white glue about ¼ inch (6 mm) thick on top of the salt. Add beads for sprinkles and any other toppings to your smoothie.

3 | Let dry overnight.

Pro Art Tip

Be careful not to wiggle your straw around after the smoothie is dry. It may cause the glue to come loose.

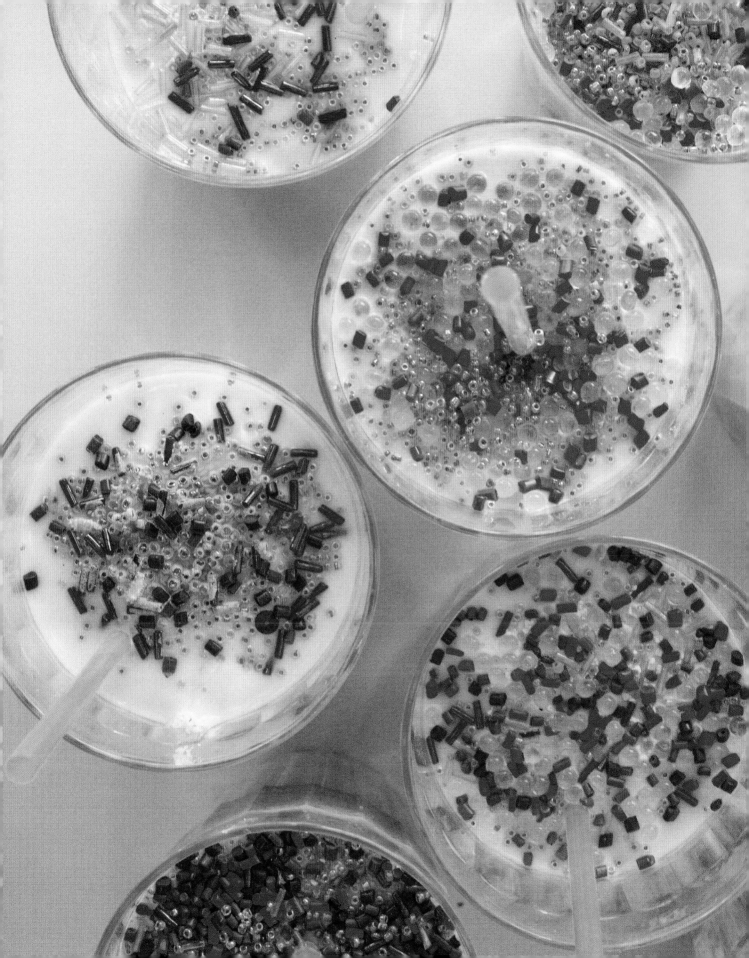

Clay Donuts + Stand

Materials

air-dry clay

tempera paint and paintbrushes

embellishments (colored sand/salt, glitter, fish tank rocks, sequins, etc.)

white glue

dowel

wood block

small piece of paper

markers

It's no secret that most kids love donuts, but even if they don't like eating them, they will love making them. This process is super fun and great for kids of all ages. Plus, you can celebrate with a super-delicious box of real donuts after you're done with your creations.

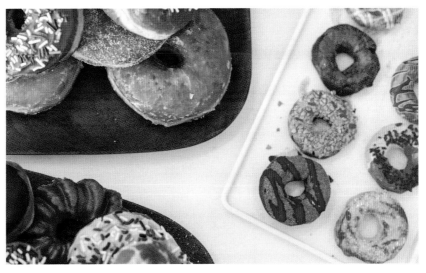

PROCESS

1 | Use air-dry clay to make donut rings. We rolled a thick snake or log first and then connected the ends.

2 | Paint the donuts and then dip them in the colored sand or salt. Add additional embellishments as desired.

3 | Let the donuts dry overnight.

> **Pro Art Tip**
> *We love IKEA mala paints to make icing marks, or you can make your own by using squeeze bottles filled with paints. (We like the Nancy brand of bottles, which can be found online.)*

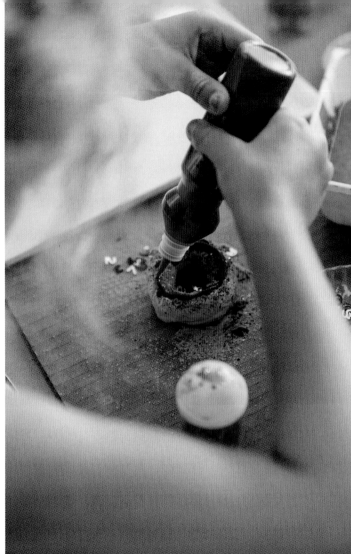

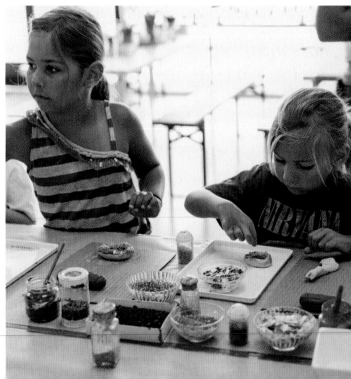

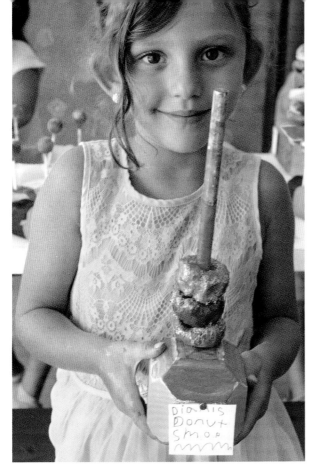

4 | Glue a dowel onto your wood block and invite your child to paint it. This becomes your donut stand. When it's dry, slide your donuts over the dowel to display. When making the donuts, be mindful of making the holes of your donuts big enough to slide over the dowel.

5 | Use a small piece of paper to make a sign for your donuts (e.g., "Diana's Donuts").

6 | When kids are done they can place their donuts on a tray and use them for observational drawing. We love drawing and painting what we make.

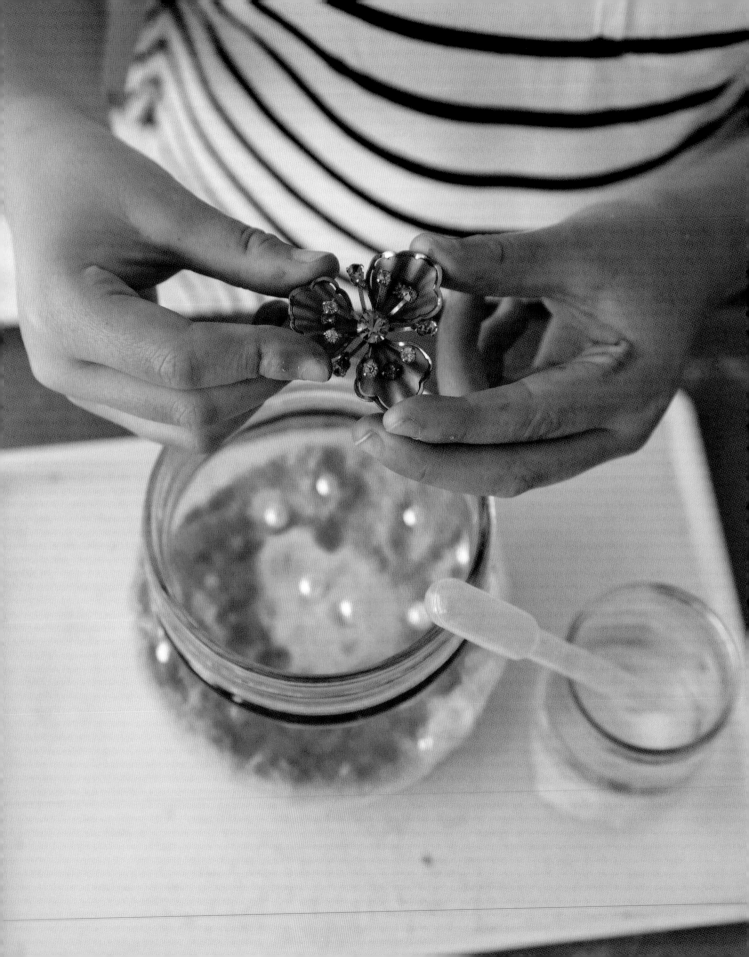

Potions (Two Ways)

Materials

dyed salt in separate bowls (see page 112 for dyeing salt)

spoons

funnel

clear container or jar (We buy large jars at our local dollar store. We like them because of the wide top and sturdy bottom.)

water in jars

pipettes

little trinkets and small beads for treasures

glitter (optional, but awesome)

This is another Gigi and Diana special. My girls are not always so big into drawing, but man, do they love a good potion. There are so many ways to make potions. These are two of our favorite ways to do them. You can call your "potions" anything you want. We've called them unicorn potions, fairy potions, nature potions, witches' brew, magic potions . . . you name it.

MAGIC POTIONS

PROCESS

1 | Invite your child to spoon different colors of salt into a clear container or jar to create their potion. They can add small drops of water as desired as they go. Some kids like to add a lot of water, while others use more salt. It's really up to the individual.

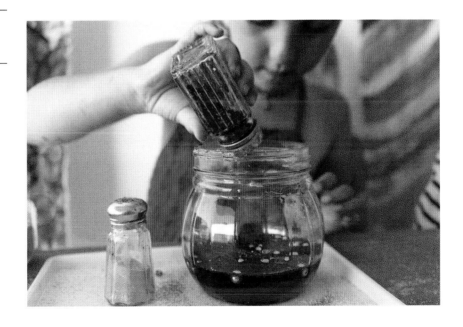

2 | As they work, kids can add "treasures" to their potion. We explain that the small beads and trinkets are very special, as they add the magic to give the potions their powers. Treat them with care. This will help prevent kids from dumping things in their potions. You might want to demonstrate one-at-a-time placement as well. Glitter is also a fun addition.

3 | Kids can work for as long as they want creating their potions. Some potions are good for saving, and some are fun just for making. If you want, you can create your potions directly in a container with a lid so there is no need to transfer anything. Just close up your potion when you're done, make a fun label, and you're good to go.

You might say, "These are very special treasures that will add strength and power to your potions. You want to be very delicate with them and place them in your potions with great care."

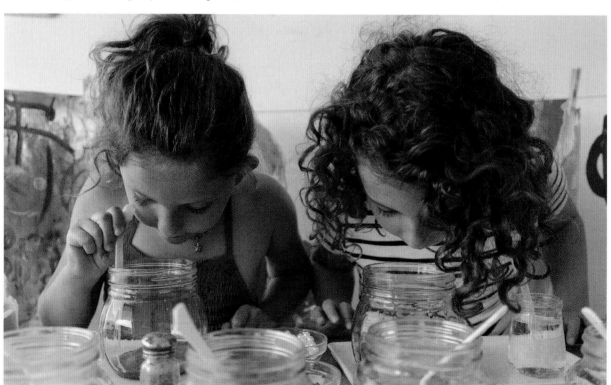

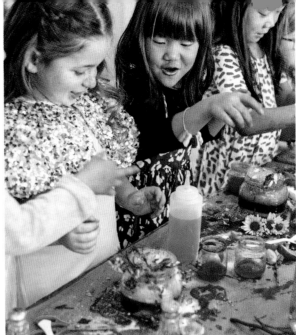

FAIRY POTIONS

PROCESS **1 |** Invite your child to start their fairy potion by clipping bits of flowers and leaves into their jar. Demonstrate how to work carefully to put the exact petals and pieces they want to make their potion powerful. I recommend keeping the other materials out of view at this point.

2 | Once they have some petals in their jar, introduce the technique of dropping in different watercolors to add liquid.

3 | When your child is ready, introduce citrus fruit, baking soda, and vinegar. Demonstrate how to carefully add the different materials to their potions. The baking soda and vinegar will create a bubbly chemical reaction when mixed, causing oohs and ahhs from your maker. A similar reaction happens when you squeeze lemon over the baking soda. Continue this process for as long as your child is interested. You can bring out glitter too, adding a sparkly dimension to their potion.

Materials

various flowers or plants	pipettes
scissors	cut-up citrus fruits
clear container or jar	baking soda
liquid watercolors in jars	vinegar colored with food coloring in squeeze bottles
	glitter (optional, but awesome)

Pro Art Tip
These potions are temporary and will go bad over time. Enjoy them while you can and then toss.

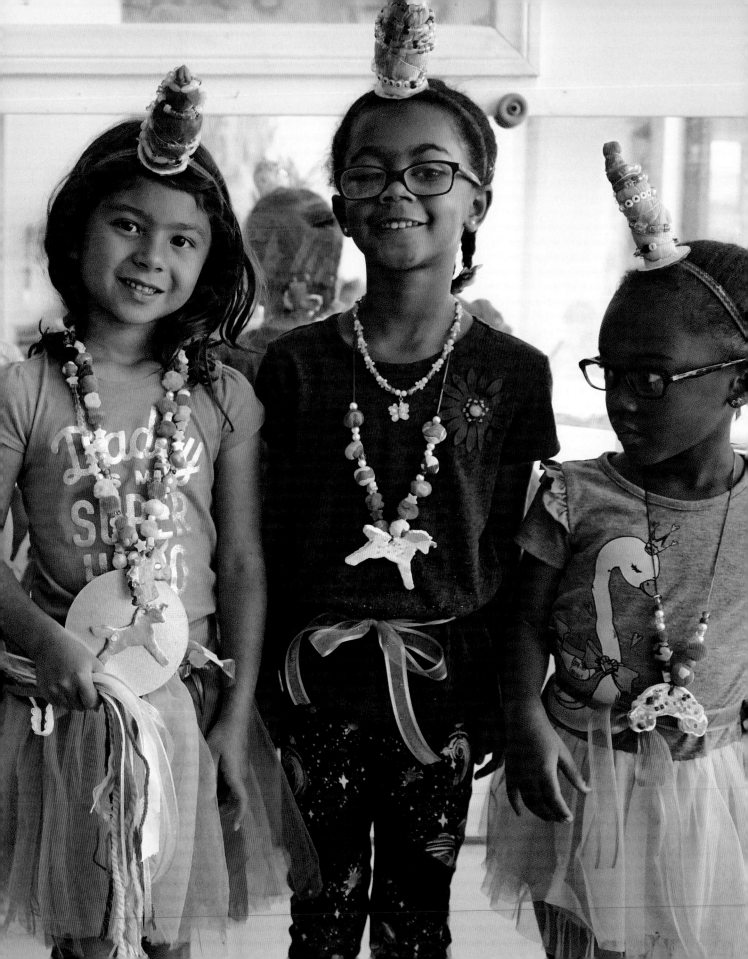

Unicorn Horns

Materials

white tights or a
thin, long sock

any kind of stuffing/
batting for your
horn (Even cotton
balls will work!)

beads and wire

scissors

neon tempera cakes
or watercolor palette
and brushes

white glue and brush

glitter (optional)

small piece
of cardboard

glue gun

elastic or yarn

Who doesn't love unicorns? It seems like they are everywhere these days. My girls can't get enough of them. So, of course we had to make our own unicorn horns. I mean, who else was going to do it? And they came out so great! This is such a fun activity that can lead to even more play.

PROCESS

1 | If you're using tights, cut the foot off about 8 inches (20.3 cm) from the bottom. Invite your child to stuff the cut tight or sock with batting—but don't make it too thick. Don't worry if it looks really weird. You'll use the wire to give the horn its shape. Tie a little knot at the end.

2 | Bead about 12 inches (30.5 cm) of wire. You can close the ends with a loop of wire so the beads don't fall off. Wrap that wire around your horn, starting from the part you want to be pointy. It may take some finessing to get the shape just the way you want it. You should squeeze the wire at the beginning and then lessen your wire grip as you go. At the bottom, tuck the end of the wire into itself. Cut the little knot in your tights to a stub.

3 | Kids can use a small brush to paint between all the wire with their favorite paints. They can add white glue with a brush and sprinkle with glitter too, just to make it extra magical.

4 | Let it dry. Then cut a circle out of cardboard to match the bottom of your horn and adhere it with a glue gun. Use ample amounts of glue and firmly press the cardboard onto the horn. Once dry, use the glue gun to attach a piece of elastic to the cardboard with enough excess that you can tie it on your child's head, like a headband. Now go sprinkle magic all over the place, you little unicorn.

Pro Art Tip
Extend this activity by creating a follow-up Invitation to Play. Make a little sign that says, "Search for Unicorn Treasures." Hide some gems throughout your backyard or home and leave your child a little pouch or box in which to collect them.

Sweet Stuffies

Materials

white cotton fabric

template to trace of your favorite sweet treat (or go freehand)

pencil or marker

your favorite water-based paints (We used neon tempera cakes.)

paintbrush and jar of water

adult scissors

glue gun or needle and thread

stuffing or batting

white glue and brush

your favorite embellishments (e.g., pom-poms, craft flowers, yarn, felt shapes, etc.)

Get ready for the sweetest little stuffies you ever did see. These are an all-time favorite, with limitless possibilities. Plus, they are great for multiple age groups. You can do sew or no-sew and go really big or super small. We've done both and they are all awesome.

PROCESS

1 | Start with your fabric stretched out on a big table. Have your kids trace or draw their favorite sweet treat onto the fabric in pencil or marker and paint the treat. Water-based paints, such as watercolors, work best for this because the paint doesn't dry hard. Let dry.

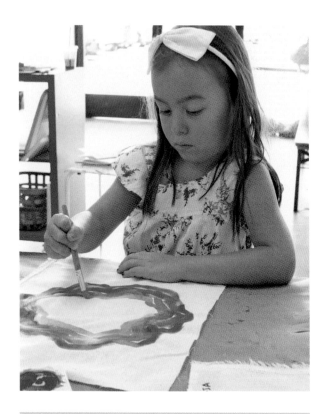

2 | Double your fabric behind your sweet treat and cut out the sweet shapes so you have a back and front.

3 | Use a hot glue gun to glue the front of the stuffie to the back along the seam, leaving a little opening for the stuffing. Invite your child to stuff their pillow and then glue the last bit closed.

4 | Kids can add as many embellishments as they'd like, using white glue and a brush. Allow to dry, and you've got a super sweet stuffie to love.

Pro Art Tip
These steps make great multiday invitations. One day can be painting, and the next can be embellishing.

Using a Glue Gun

Only you, as the parent, can decide if your child is ready to work with a glue gun. It all depends on your comfort level. I taught my daughters to use a glue gun at age four, always supervised. Now, at ages six and seven, they both handle a low-temperature glue gun with ease independently. Have they ever gotten minor burns? Yes. Has it stopped them from using the glue gun? No. Has it taught them resiliency and grit? Yes.

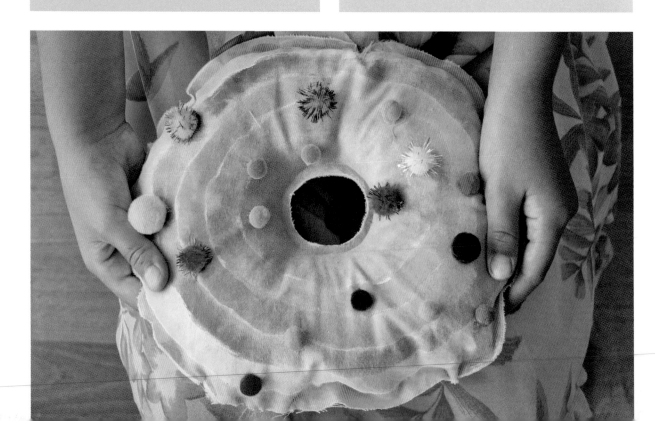

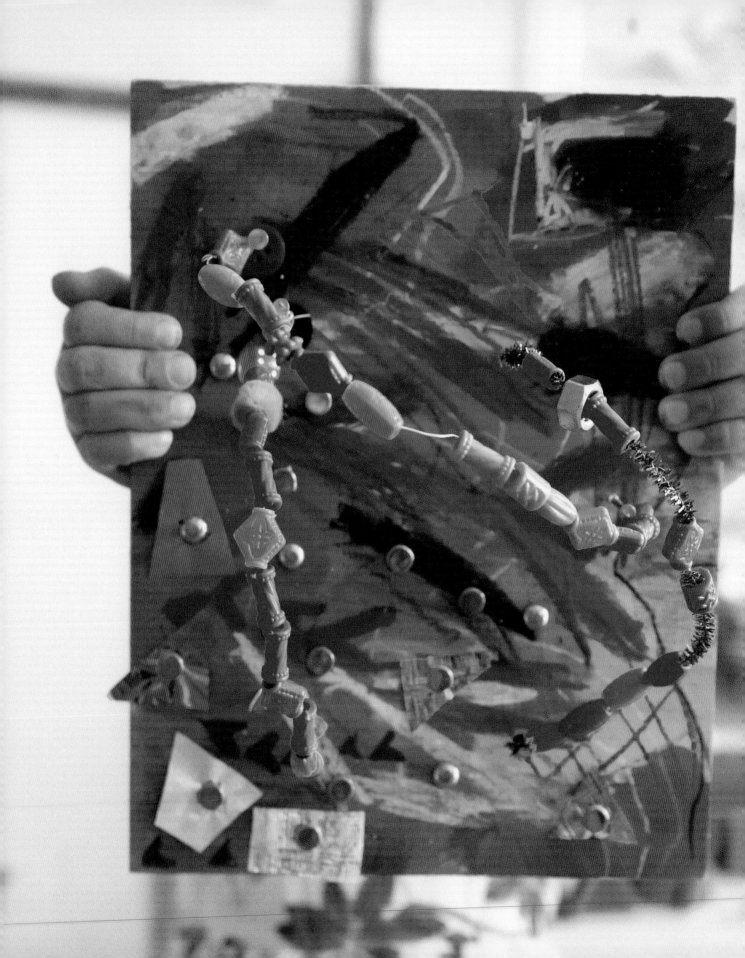

Crazy Contraptions

Materials

wood base

sandpaper or
sanding block

oil pastels
or markers

liquid watercolors
or palettes
and brushes

hammer (Your
local hardware store
might sell a small
hammer similar to
the one pictured on
page 135.)

nails

upholstery heads
(If you can get your
hands on some,
they are amazing.)

wire

pipe cleaners

beads

white glue

glitter (optional)

I love crazy contraptions. They expose children to so many thinking ideas, possibilities, and experiences. First, anytime you put a hammer in a child's hand (in a safe environment, of course) you're doing them a service. A hammer is an important tool and kids light up when they have the opportunity to use one.

Giving Kids Real Tools

I firmly believe that if we raise the bar for children and what they are capable of, they will not only meet us there, but will also surpass our expectations. That doesn't mean you give your three-year-old a hammer and say, "Have fun!" It just means that if we send our children the message that we trust them, that they can handle important tools and responsibilities, then we are more likely to see them act in a way that affirms this kind of thinking.

PROCESS

1 | Start by inviting your child to sand his or her wood with sandpaper or a sanding block. This is another example of using real tools with your children. Kids gain confidence by using real tools, and sandpaper is a fun one they can really get into. Run a finger around the wood to test if the wood is smooth.

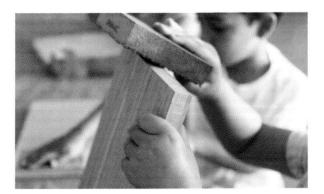

Pro Art Tip
You might want to do a little pre-sanding for your children if your wood is very rough. We don't want any splinters.

2 | Once your wood is nice and smooth it's time to work on the base of your crazy contraption. This is where the ideas for what the contraption will do start to come to life. Kids can use markers or oil pastels to start making marks on the wood and draw anything they want. After the pastels, introduce liquid watercolors to go over the wood base.

Pro Art Tip
I like to tell kids that oil pastels and watercolors are not friends. They are enemies. When the watercolors try to go over the pastels they say, "Hey, you can't cover me, get off me, we're not friends." It's a fun introduction to the chemical reaction of oil and water. Oil and water may not be friends, but science and art are besties.

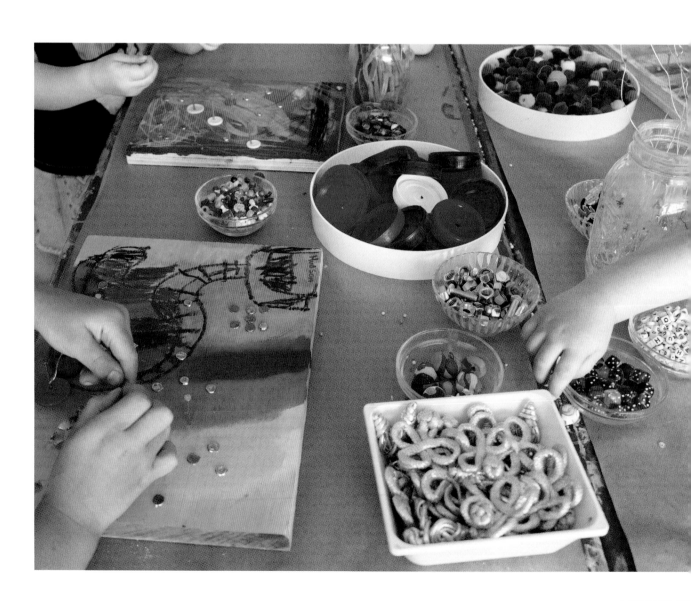

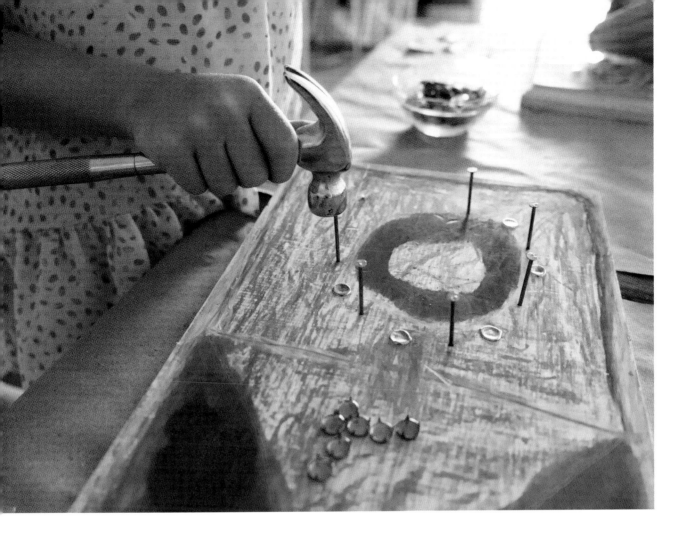

3 | Once the wood is decorated to your child's desire, it's time to start making their contraption. I recommend each child hammer at least five nails into their wood before going to the next step.

You can assist with the nailing, though many children are capable of hammering on their own. I always go over safety tips first: Your eyes stay on your work so you don't accidentally hammer your fingers. Hold the nail toward the bottom area and press it onto the wood. Hit the nail on the nail head until it goes into your wood, then move your hand and give the nail a few more taps.

You can also hammer the nails in for your child, having him or her point to the desired spot. Once the nail is in a little, let the child do the rest. Do what feels comfortable. If you can get your hands on some upholstery heads those are great, because they can stand on the wood without being held and kids can just hammer them in. Hammer in as many nails as you want and you'll be ready for the next step.

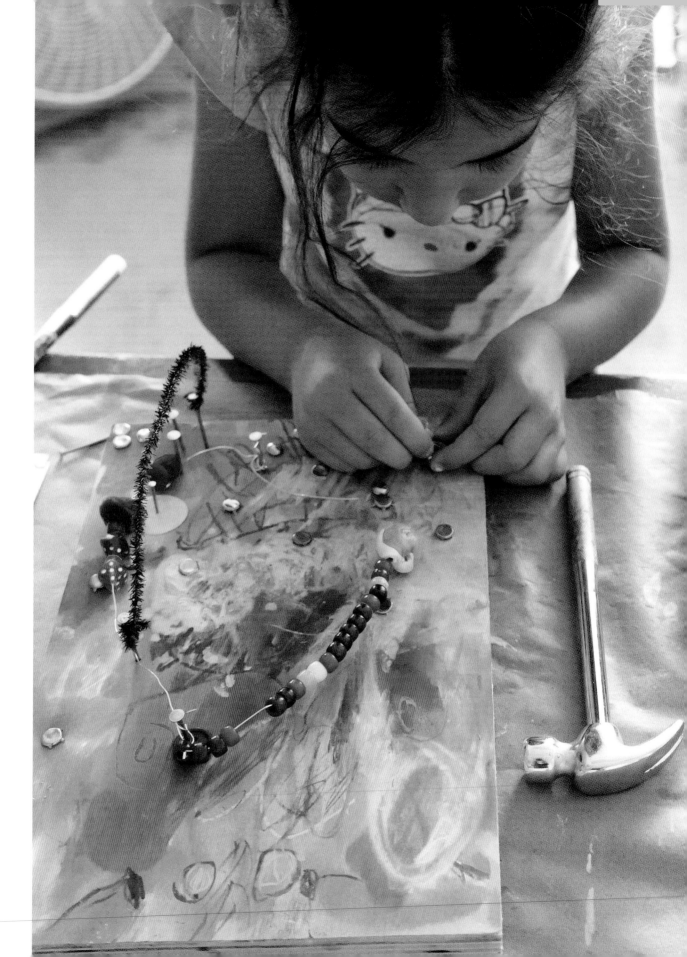

4 | Your child can wind cut wire and pipe cleaners around the nails for their contraption. Adding beads to move across the wires makes the contraption come alive. Attach the beaded wires from nail to nail.

5 | Add glue and glitter, if desired, and any last details, words, or signs to the contraption.

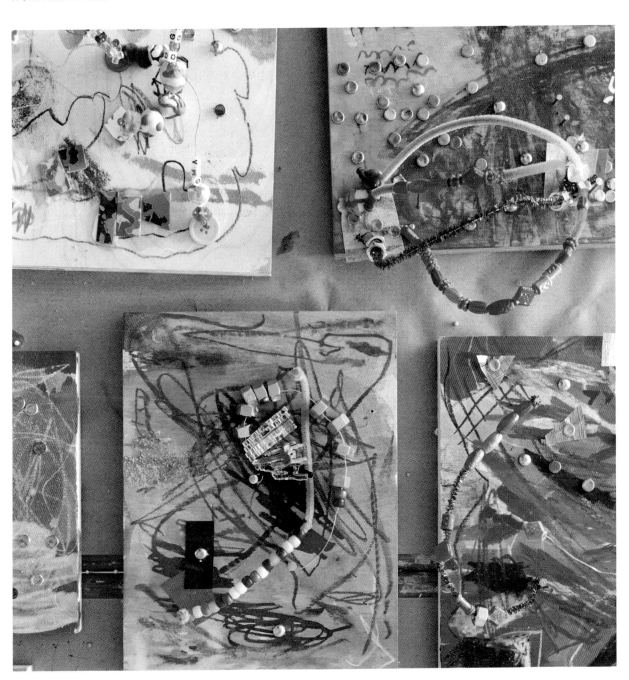

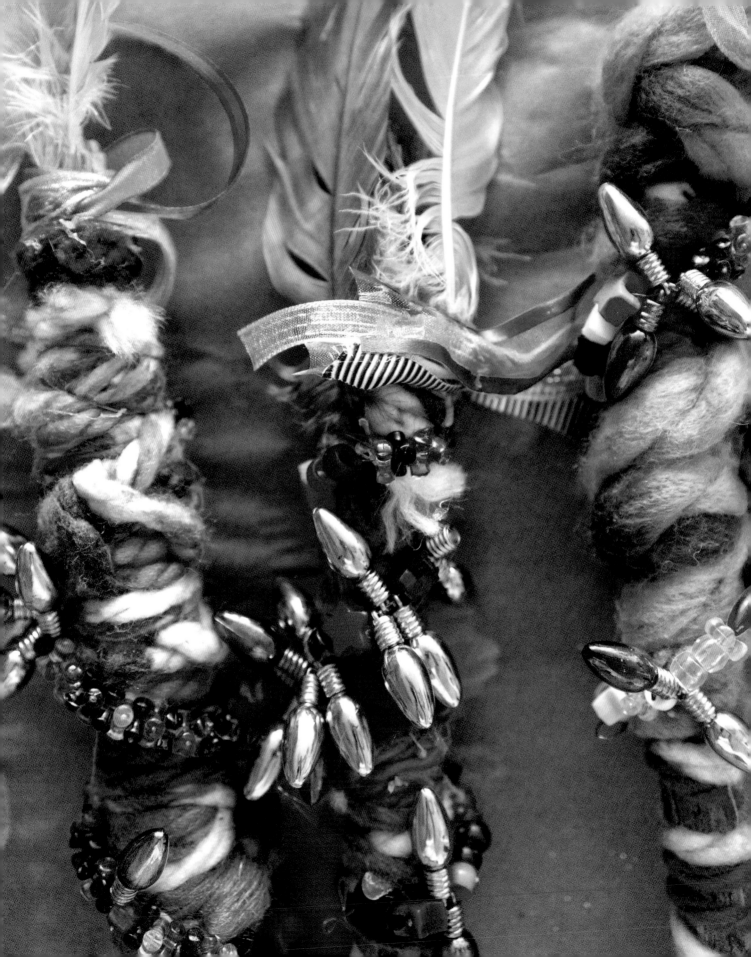

Magic Wands

Materials

stick (great excuse to go on a nature walk with your child)

yarn

glue gun

wire and beads

feathers (optional)

ribbons (optional)

Wands can be used in many imaginative ways and can meet the interest of your child across many different themes. You can make Magic Wands, Princess Wands, Fairy Wands, Nature Wands, Celebration Sticks . . . you name it. Wand making can look a lot of different ways too. We incorporate a few fun techniques that provide important gross and fine motor practice for kids of all ages.

PROCESS

1 | The first step is to wrap your stick in yarn. This may be challenging for some young children, which is a great reason for them to give it a go. Knot a piece of yarn to one end of a stick, and your child can wrap it around, holding the string in one hand and the stick in the other. Another technique is to roll the stick on the table or twist it in your hand, round and round, and let the yarn wind around the stick. Different children prefer different techniques. You can use a glue gun at the end of your stick or tuck the yarn under the last wrap. (A glue gun is easier.) Keep wrapping the stick with more pieces until it is covered. A child who can master wrapping their stick will feel full of confidence. This invitation is great to repeat every few months until they really get it.

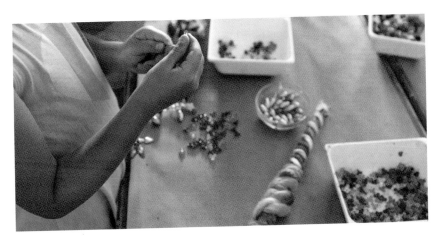

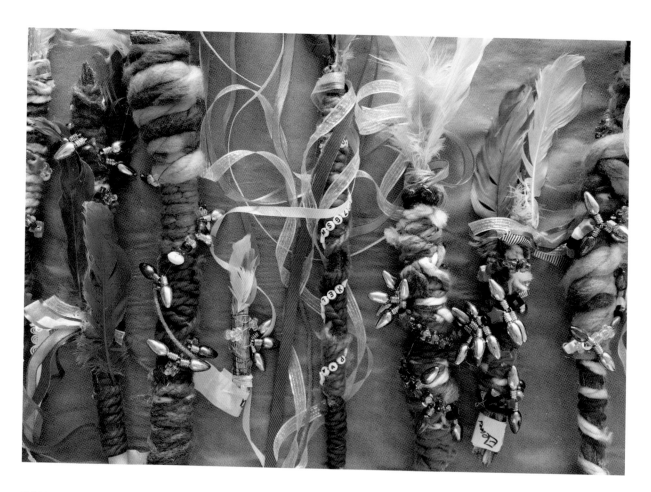

2 | Next, get out a long piece of wire and encourage your child to string it with their favorite beads.

3 | Wrap the beaded wire around the wand. Lastly, your child can attach feathers and ribbons to the top of the wand to make it extra magical. You can either stick the feathers into the yarn or attach them with a glue gun. The ribbons can be tied or glued on as well.

4 | The last step is the most fun—play with your wand. Have fun! I hope it works some major magic.

"My magic wand turns me invisible.
Poof. I'm gone."
—Meri, age 44

Pendant Necklaces (Two Ways)

Materials

kid's scissors

cardboard

washi tape, stickers, or other embellishments

hole punch

string or lanyard

beads

We love making pendant necklaces. This is a great playdate or birthday party activity, or just a great one-on-one invitation. You can go the recycled route, which is super easy, or the clay route, which is also easy but requires more materials. You decide.

RECYCLED PENDANTS

PROCESS

1 | To make a recycled pendant, cut out a cardboard circle about 3½ inches (9 cm) in diameter. Kids can decorate the pendant with washi tape patterns, color with paint markers, cover with stickers, add pom-poms, etc. Their choice. Use a hole punch to make a hole at the top and glide two ends of a cut string or lanyard through the hole, pulling them through the loop of string like a luggage tag. This will help the pendant lie nice and flat.

2 | Add beads to either side of the string and tie together for a necklace. We've found the best way to tie a necklace together without it falling apart is to put the two ends together and make a double knot, so it's like you're putting a knot into the string. Add as many fun beads as you want. We love to cut up straws and use our own clay beads (see page 63). Wear and enjoy!

roller

air-dry clay

parchment paper
or tinfoil

cookie cutters

toothpick

tempera paint
and skinny brush

embellishments
(gems, sequins,
small beads, etc.)

white glue and brush

string or lanyard

beads

CLAY PENDANTS

PROCESS Hopefully you've had a chance to try out air-dry clay in the donut project (pages 117–119) or candy boxes (pages 147–148) projects. It's easy to work with and kids really like it. I like to come up with projects in which you can use materials you've already purchased, prepped, and are familiar with, so there are tons of repeats throughout this book.

1 | Roll out some air-dry clay onto parchment paper or tinfoil, about ¼ inch (6 mm) thick. Don't roll your clay too thin or it will likely break later. Invite kids to cut out their favorite shapes with cookie cutters. They can cut out as many as they like. Poke a hole at the top with a toothpick or another sharp tool for hanging later. Make sure the hole is big enough for your string or lanyard.

2 | Paint and embellish the pendants with tempera paint and a skinny brush. (See how we do paint mixing with kids on page 93.)

Pro Art Tip
You can also turn your pendant into a pin by gluing a pin from your local craft store onto the back. This is a great option if your child doesn't like to wear jewelry and wants to add something to his or her backpack.

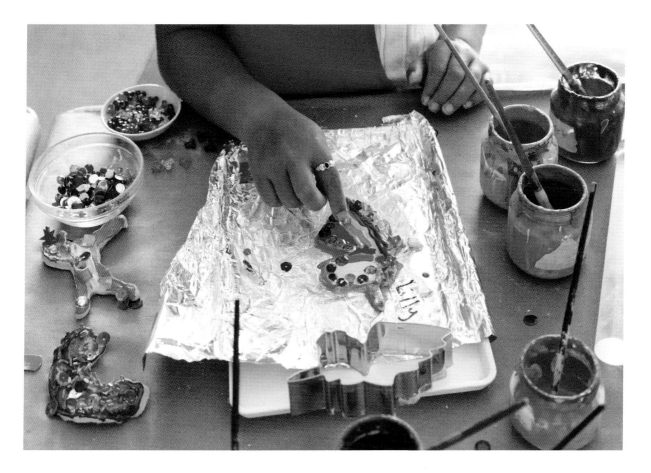

3 | On top of the paint, kids can add all their favorite embellishments by pushing them into the clay and paint. Allow the pendants to dry and then paint both sides with white glue. This will help everything stay together.

4 | Lastly, string and bead your necklace, following the same steps in the recycled pendant instructions. Wear and enjoy!

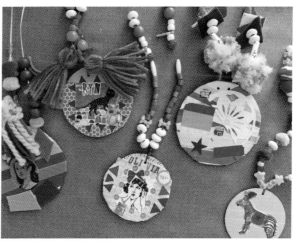

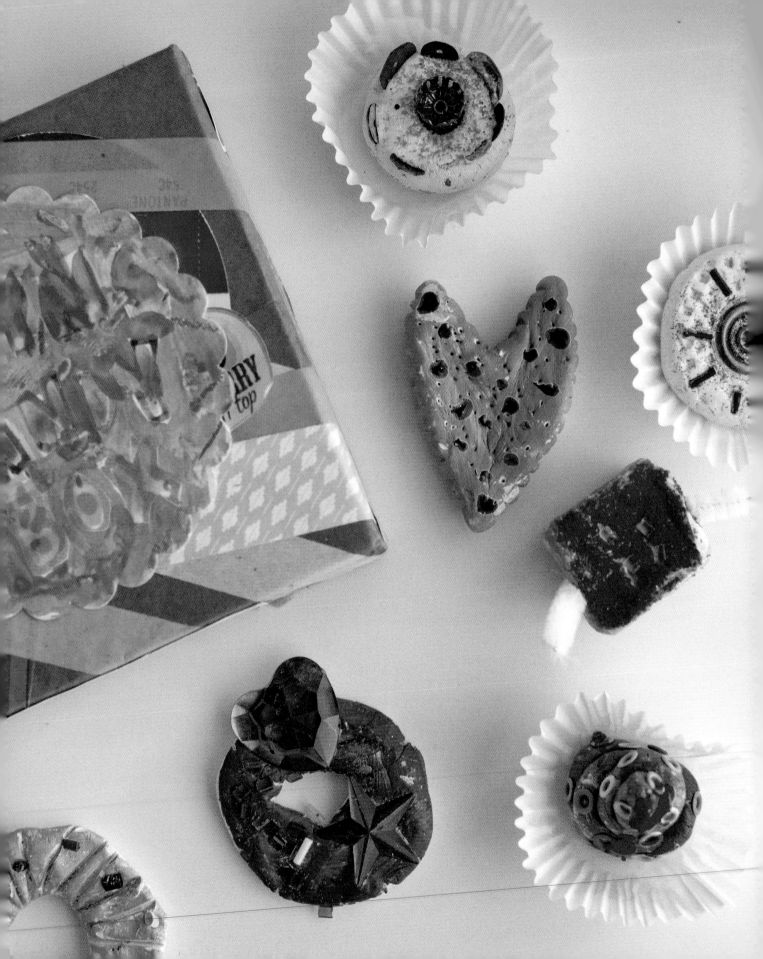

Candy Boxes

Materials

air-dry clay

parchment paper
or tinfoil

tempera paint and
small brushes

embellishments
(glitter, sequins,
beads for sprinkles,
mala paints, tempera
paints, colored sand
or salt for icing, etc.)

candy box

cardboard divider
for your box

washi tape, colored
paper, and markers

white glue

cupcake liners

We love to use air-dry clay in as many ways as we can think of. Candy boxes were a great discovery of our studio friend, Charlotte. This project is similar to donut making (see page 117) in that kids get to use a buffet of interesting materials and their imagination to make and decorate their candies any way they'd like. Kids LOVE making their own candy. This is such a fun activity.

PROCESS

1 | First, invite your kids to make some candies from air-dry clay. You can print out some examples or demonstrate some of your own ideas. I like to have a few already made to inspire ideas. It's okay for you to have some fun too. You can do spirals, cubes, little balls . . . whatever works. Just make sure they aren't too big to fit into a cupcake liner. Line up the clay candies on a piece of parchment paper or tinfoil.

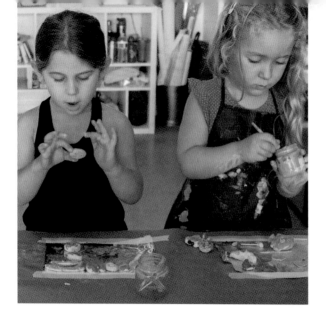

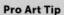
3 | Create the box. When we first did this project, we made our own little dividers in the box from cardboard. We've since discovered that the square gift boxes at your local craft store are the perfect size for a double-decker candy box. You can fit four cupcake liners on each level. Just place a square piece of cardboard between the layers that is a little smaller than the size of the box. Kids can decorate their box with washi tape, markers, and glued-on papers.

2 | Introduce paint with small brushes and the embellishments you gathered. The kids can paint, add sprinkles, icing, and little treats on each one. Let these dry overnight.

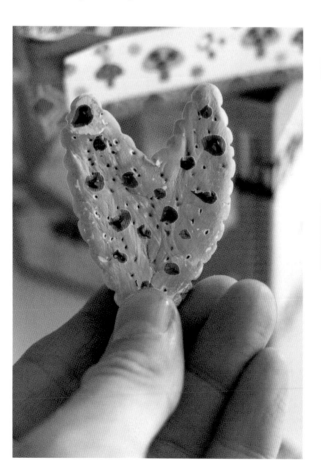

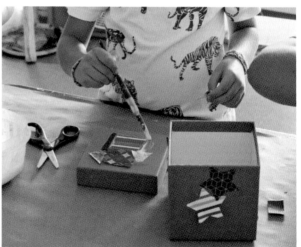

4 | When all your candies are dry, place each one in a cupcake holder inside your box. You have the perfect candy box for hours of imaginative play.

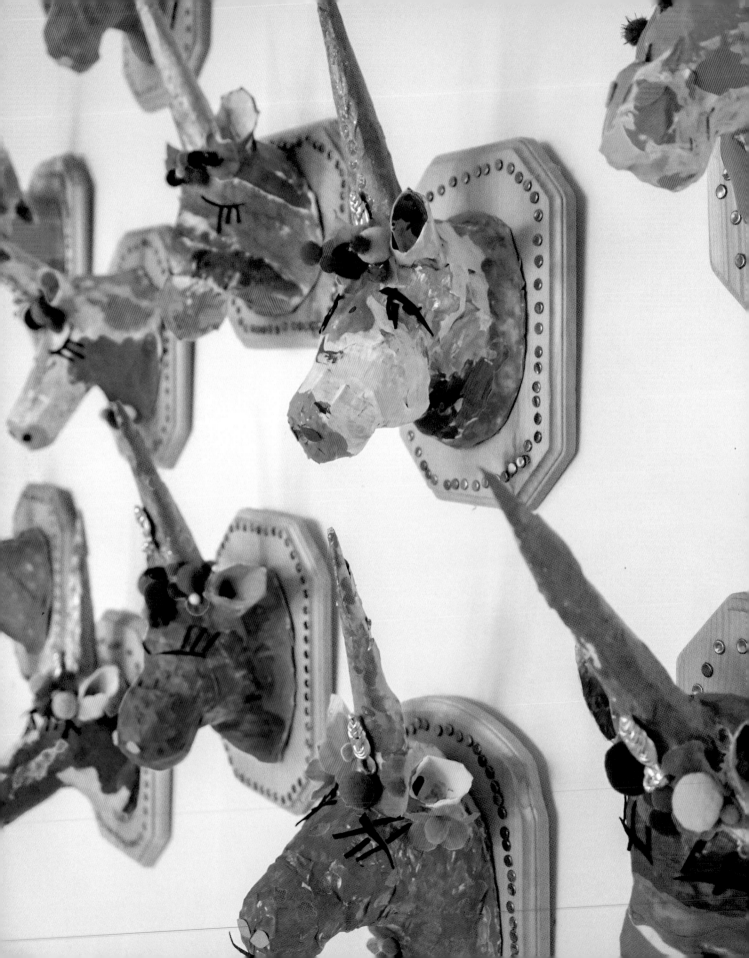

Papier-Mâché Unicorns

Materials

4 newspaper balls
(3 medium, 1 large)

masking tape

a cardboard oval
(4 x 6 inches
[10 x 15 cm])

2 pieces of white
cardstock for the
horn and ears

papier-mâché mix
(3 parts flour,
2 parts water,
1 part white glue)

newspaper strips

white gesso
and brushes

tempera paint

glue gun

a wood plaque

embellishments
(pom-poms, ribbon,
glitter, etc.)

white glue

glitter (optiona)

hammer (optional)

upholstery studs
(optional)

Disclaimer: Papier-mâché is probably the most challenging process in this book. Some kids love papier-mâché and some don't. It's a texture thing. I like to tell kids this upfront and then say, "I wonder how you're going to feel about it?" We always encourage kids to try it and then help those who don't like it. That's totally okay. And if they don't like the form-building part, they may really enjoy painting the final figure—so remind them that there are a few stages to this project. Our job as parents and educators is to help our children take risks even if they have apprehensions. They will inevitably have discoveries that they had not anticipated. These unicorns bring so much joy to everyone they meet, so even though they aren't process art in the respect that there is a very clear result, the process to create them is pretty epic—we just had to include it here. You can start with a much simpler shape, like your favorite fruit, as an introduction on to papier-mâché.

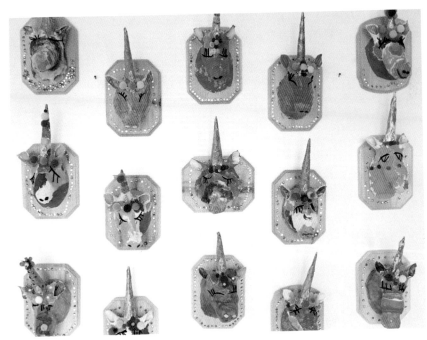

PROCESS

1 | Create one large- and three medium-size newspaper balls. Wrap your balls in masking tape until they feel secure. Attach your largest ball to the cardboard oval for the neck with masking tape. Tape the three medium-size balls to the neck one at a time, building your unicorn head and snout. This may take some finessing to get the desired shape. Try building down as you go.

2 | Create a cone shape from cardstock and secure it with tape to the head for the horn. Fold two ears from cardstock triangles by taping two of the corners together and attach those pieces to the head with tape.

Pro Art Tip
Encourage kids to create their snout. We used adult help to attach the horn and ears, and helped out with the snouts. Teamwork is great when needed.

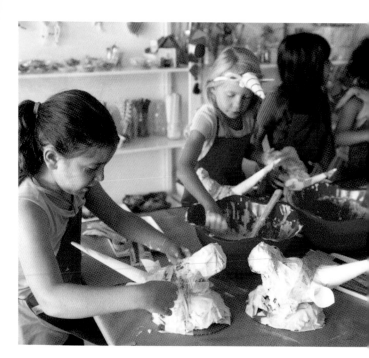

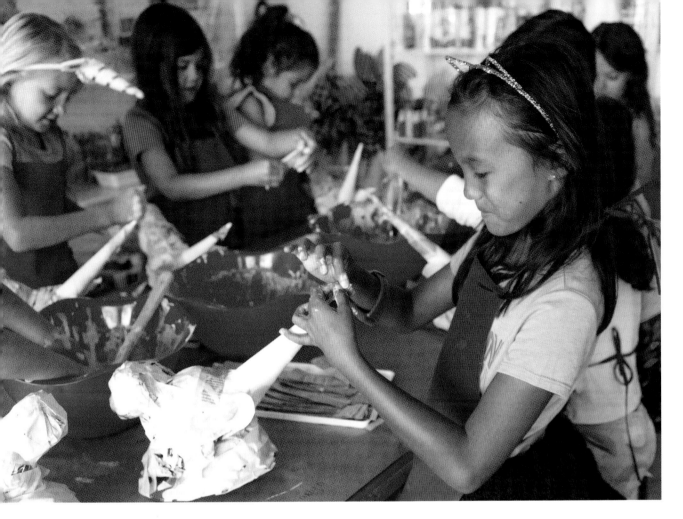

3 | Papier-mâché time! Mix three parts flour, one part glue, and two parts water in a bowl. Dip the newspaper strips in the mix and wipe off the excess mix with your fingers or the side of the bowl. Cover your entire unicorn with two or three layers of paper strips and let dry. We've found it's best to let papier-mâché projects dry in the sun, if possible, to prevent any mold from forming. (They will probably need at least 24 hours to dry.)

4 | Once dry, paint the whole unicorn with white acrylic or gesso. This creates a nice base for painting and dries quickly. Invite your child to paint their unicorn with their favorite unicorn colors. Let dry. Use a glue gun to attach the dry unicorn to your wood plaque.

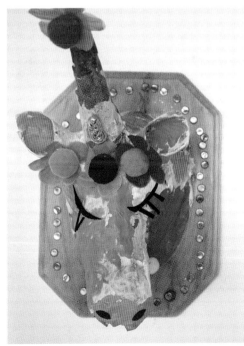

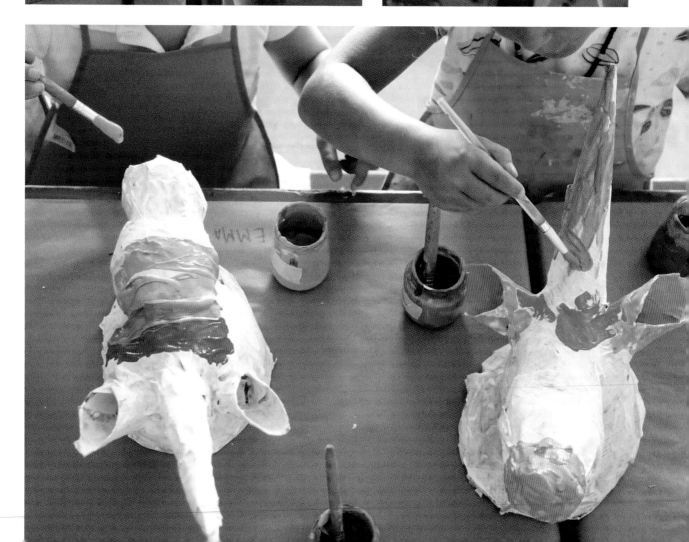

5 | Add details with a glue gun to make your unicorn extra special. We used cut felt for eyes and eyelashes and pom-poms and flowers for a crown. We also brushed white glue onto the horn and sprinkled on glitter. Feel free to add whatever details you want.

6 | Your unicorn is now ready to hang and enjoy. You did it! You are officially a crafting superstar.

Pro Art Tip
We hammered upholstery studs into the plaque. If you can get your hands on some, we highly recommend them as a fun accent, but they are totally optional.

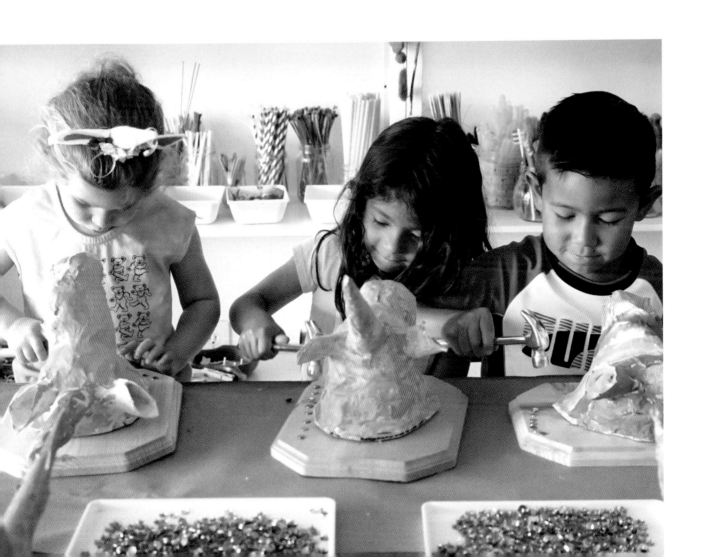

FINAL NOTES

I hope that this book has provided you with concrete, easy-to-manage ideas for incorporating process art and Invitations to Create into your life. I continue to learn from my experiences and still remain somewhat in awe over the magic of process art.

Like many moms, I often look for opportunities for my children to have valuable experiences that feel organic and meaningful. It's not always easy. When I sat down to make Artist Trading Cards with my family earlier this year, my daughter Gigi had the idea to give the cards to kids in the hospital to make them feel better. It was a poignant mom moment. My husband, Ev, looked at me and smiled, and as a family we created a plan and began putting the trading cards together in packs so we could bring joy to kids in the hospital while teaching our children a valuable lesson about giving. Or, are they teaching us?

Over the next few months, kids of all ages jumped in and helped us create hundreds and hundreds of Artist Trading Cards. For my birthday, when my husband asked me how I wanted to celebrate, I said I wanted to go deliver the cards to the hospital as a family. So, that's what we did. Here we are at Children's Hospital in Los Angeles delivering the Artist Trading Cards packs and some art supplies, so the kids at the hospital can make their own. Our hope is that this is something that continues and spreads creativity and joy for all the participants.

I wanted to share our experience because to me, this is what process art is really about: being open to a moment of magic, catching it, and going someplace unexpected and beautiful, all because we created together.

Wishing you magic through the process,
Meri Cherry

ABOUT THE AUTHOR

MERI CHERRY has more than twenty years of teaching experience, working with children through process art—art that is all about the making and the doing, rather than the finished product. Meri's blog, www.mericherry.com, has set the standard for meaningful and enriching process-art experiences that are both manageable for parents and engaging and fun for kids. Meri has collaborated with brands like Oriental Trading Company, Kid Made Modern, Mixbook, and Discount School Supply. Meri Cherry Art Studio has become a destination spot for parents and children throughout Los Angeles, and her studio was voted one of the top seven birthday party venues in Los Angeles by *Red Tricycle* in 2017. Meri has helped thousands of parents all over the world bring more art into the lives of their children, students, and families. Meri is a wife and the mother of two girls and lives in Los Angeles, California.

For more inspiration and resources, visit Meri's blog and follow her on social media:

Website: www.mericherry.com

Instagram: @mericherryla

Facebook: facebook.com/MeriCherryBlog

Pinterest: pinterest.com/mericherry

ACKNOWLEDGMENTS

I am deeply grateful to my husband, Ev, and my daughters, Gigi and Diana, who not only gave me the support and time I needed to write this book, but also participated in more photo shoots than they probably care to remember. You guys are my endless inspiration and I'm so blessed and grateful to call you my family. I love you most.

To my second family, the team at Meri Cherry Art Studio. I couldn't do this without you guys. Thank you for everything you do to keep the magic alive, day in and day out. I know what it takes and I am so, so grateful.

To all the kids who appeared in this book and had fun making art with us. THANK YOU!

Thank you to Mary Ann Hall and the team at The Quarto Group for bringing this vision to reality. It has been a pleasure working with you.

And lastly, to the moms. To every mom who came out to my backyard for play group. To every mom who called and asked me to teach an art class. To every mom who told her friends about the studio. To every mom who follows along with words of encouragement and love on Instagram. Thank you. I wrote this book for you.

May we all continue to experience the magic of process art together for years to come.

INDEX